TATE TRIENNIAL 2006
NEW BRITISH ART

Edited by
BEATRIX RUF and **CLARRIE WALLIS**

With an essay by
JAN VERWOERT

Contributions by
**GAIR BOASE, SIOBHAN McCRACKEN, EMILY PETHICK,
KATHARINE STOUT, CLARRIE WALLIS, CATHERINE WOOD**

Tate Publishing

First published 2006 by order of the Tate Trustees on the occasion of the
exhibition at Tate Britain 1 March–14 May 2006 by Tate Publishing, a division
of Tate Enterprises Ltd, Millbank, London SW1P 4RG
www.tate.org.uk/publishing
© Tate 2006

British Library Cataloguing in Publication Data
A catalogue record for this book is available from the British Library

ISBN-13: 978 185437 622 0
ISBN-10: 1 85437 622 5

Distributed in the United States and Canada by Harry N. Abrams, Inc., New York

Library of Congress Cataloging in Publication Data
Library of Congress Control Number: 2005933812

Designed by Kerr | Noble

Cover: Original artwork by Liam Gillick
Designed by Simon Esterson Associates

Printed in Spain by Grafos

Measurements of artworks are given in centimetres, height before width

CONTENTS

FOREWORDS

AND

ACKNOWLEDGEMENTS

Funder's Foreword

The support given to the *Tate Triennial* by the UK Branch of the Calouste Gulbenkian Foundation in our fiftieth anniversary year reflects our long association with Tate. The relationship began in the 1960s with the seminal exhibition *54/64: Painting and Sculpture of a Decade*, the first major international survey of post-war contemporary art to be held in Britain. Funding towards the galleries in which the *Tate Triennial* is shown today was given by the Foundation in 1969 to mark the centenary of Calouste Sarkis Gulbenkian's birth.

The Foundation's collection of British art, held in the Centro de Arte Moderna in Lisbon, is one of the largest outside the UK, with a particularly strong focus on the 1960s. A selection of works from the collection is on display at Tate during the *Triennial*.

A commitment to encouraging artists to experiment remains central to the Foundation's current arts programme. The same spirit is clearly evident in the works included in this year's , and we are delighted to be so closely associated with Tate once again.

Paula Ridley
Director, Calouste Gulbenkian Foundation, UK Branch

Foreword

This catalogue is published to accompany the third *Tate Triennial* – an exhibition of new and recent British art. It continues a series that began when Tate Britain was launched in 2000, and forms a vital strand in our present and future commitment to showcasing the work of contemporary British artists of all generations. Like its predecessors, this *Triennial* exhibition is driven by a strongly subjective curatorial vision rather than by any attempt to survey, summarise or encapsulate the tides of current practice. Its curator, Beatrix Ruf of the Kunsthalle, Zurich, nonetheless discerns and explores patterns linking the work of thirty-six artists – ranging from senior figures such as the celebrated Ian Hamilton Finlay to Muzi Quawson, a young photographer in her final year at the Royal College of Art. Ruf finds that the tendency to appropriate and recast visual and cultural material from the comparatively recent past, to requisition and recast it in diverse forms, has gathered particular momentum and authority, and indeed has emerged as one of the most vital characteristics of contemporary visual culture. Live Works, a programme of performance (taking place in a specially commissioned 'plaza' outside the main exhibition space), helps prove that this is a culture that cannot breathe within gallery walls alone.

Ruf's 2006 *Tate Triennial* has been shaped with the close collaboration of the artists, to whom we are profoundly grateful, and a number of curatorial collaborators at Tate. The project team was ably led by Carolyn Kerr, with Katharine Stout, Clarrie Wallis, Catherine Wood and Gair Boase, in liaison with a committed Tate delivery team. A project of this scale and ambition would have been impossible without the support, in addition, of a major funder: here we have been most fortunate to secure the generous and wholehearted backing of the Calouste Gulbenkian Foundation, who celebrate their fiftieth anniversary this year and whose services in the cause of contemporary British art – its celebration and exploration – have been remarkable.

Stephen Deuchar
Director, Tate Britain

Acknowledgements

This has been an exciting and challenging project and I am grateful to the very many people who have given their time and energy to realising the exhibition. I am especially appreciative of the participating artists for their enthusiasm and commitment, and of the many artists we visited in the process of selecting the exhibition: discussions with all of them helped shape the *Tate Triennial 2006*.

I am extremely grateful to those individuals and institutions who have kindly lent works of art to the show: Helga de Alvear, Daniel Buchholz and Christopher Müller, Mark Fletcher and Tobias Meyer, Hunter and Lisa Gray, Sean and Mary Kelly, Shirley Morales, Alexander Schröeder, Dr Reiner Speck and to the private collectors who wish to remain anonymous. I would also like to thank the UK branch of the Calouste Gulbenkian Foundation for its financial support, which made an extremely ambitious project possible.

Thanks are also due to all those who have helped realise works for this exhibition, in particular Film and Video Umbrella and De La Warr Pavilion for commissioning *Wintergarden* 2005 by Daria Martin, and the Dewar Arts Awards for commissioning Luke Fowler's new film, *Pilgrimage from Scattered Points* 2006. Thanks also to Arts Council England and Nick Corker and Josephine Pickett-Baker at Complete Fabrication Limited for their support with the production of *Robbed us with the sight of what we should have known* 2006 by Ryan Gander, and to Chris and Lone McCourt at Isokon Plus for helping with furniture for Marc Camille Chaimowicz's installation *Here and There ... 1979–2006*. I am also grateful to Barney Farmer and Lee Healey for allowing Mark Leckey to use material from *Drunken Bakers*, which first appeared in *Viz* comic in January 2003.

The artists' galleries have provided invaluable assistance: Helene Retailleau, Air de Paris; Jake Millar and Emma Robertson, The Approach; Gavin Brown and Laura Mitterand, Gavin Brown's enterprise; Katharina Forero, Galerie Daniel Buchholz; Martin McGeown and Andrew Wheatley, Cabinet; Joanna Kleinberg, Casey Kaplan; Bruno Brunnet and Nicole Hackert, Contemporary Fine Arts, Berlin; Tommaso Corvi-Mora, Corvi-Mora; Carl Freedman and Jo Stella-Sawicka, Counter Gallery; Pilar Corrias and Lupe Sanchez, Haunch of Venison; Nicky Verber, Herald St; Darren Flook, HOTEL; Magnus Edensvard and Vita Zamen-Cookson, IBID PROJECTS; Michelle D'Souza, Lisson Gallery; Victoria Miro and Nina Øverli, Victoria Miro Gallery; Salome Sommer, neugerriemschneider; Maureen Paley, Dan Gunn and Maximilian Mugler, Maureen Paley; Friedrich Petzel, Friedrich Petzel Gallery; Esther Schipper; Louise Hayward, STORE; Toby Webster, Toby Webster / The Modern Institute Inc.; Nicolai Wallner, Galleri Nicolai Wallner; Irene Bradbury and Vicki Thornton, White Cube.

I would like to acknowledge my debt to the many Tate staff who have helped bring this project to fruition. I am especially grateful to Carolyn Kerr, Emily Pethick, Katharine Stout, Clarrie Wallis and Catherine Wood, together with Gair Boase, Siobhan McCracken and Adrian Shaw. Special thanks also to Misha Coggeshall-Bur, Kenneth Graham, Gil Leung, Anna Nesbit, Andy Shiel, Shuja Rahman, Liam Tebbs and the art-handling team; Christina Bagatavicius; Rosie Blackmore, Alice Chasey, Lillian Davies, Roger Thorp and Emma Woodiwiss of Tate Enterprises. Thanks are also due to: Helen Beeckmans, Richard Cook, Laura Davies, Vanessa Desclaux, Sionaigh Durrant, Claire Eva, Rebecca Heald, Rebecca Hellen, Rebecca Hunter, Daisy Mallabar, Zeena Parkins and Piers Townshend. I would also like to thank Stephen Deuchar, Judith Nesbit, Will Gompertz and Celia Clear for their support.

I wish to express my appreciation to all those who have helped to present the exhibition: Jan Verwoert for his illuminating essay and Gair Boase, Siobhan McCracken, Emily Pethick,

Katharine Stout, Clarrie Wallis and Catherine Wood for their catalogue contributions; Frith Kerr, Amelia Noble and Ryan Ras at Kerr|Noble for their dedication to the catalogue design and graphics for the exhibition; Liam Gillick for providing the original art work for the catalogue cover designed by Simon Esterson Associates, Pablo Bronstein and Celine Conderelli for their design for the North Duveens.

The following individuals have helped and guided the exhibition in various ways: Sandy Goldberg and Nicola Wissbrock, Antenna Audio Inc., Michael Archer, Charles Asprey, Tim Bacon, Suzanna Beaumont, Claire Bishop, Juliette Blightman, Steve Bode, Fiona Bradley, Lizzie Carey-Thomas, Michael Clark, Steve Claydon, Peter Coates, Sadie Coles, Phil Collins, Stuart Comer, Susanne Cotter, Sorcha Dallas, Clarissa Dalrymple, Pauline Daly, David Dance, Sarah Davies, Jan Debbaut, Sarah den Dikken, Gregory Hardie-Eades at the Museums, Libraries and Archives Council, Siân Ede, Mark Edwards, Simon Esterson, Alex Farquharson, Ishbel Flett, Holger Freise, Martin Furler, Ann Gallagher, Cornelia Grassi, Aurelia Gressel, Christoph Grunenberg, Antony Hegarty, Matthew Higgs, Philippa Hilditch, Jens Hoffmann, Jenny Hogarth, Tom Humphreys, Hayley James, Allen Jones, Stefan Kalmar, Robert Koch, Melissa Larner, Mike Lawson, Michel Letendrie at Martinspeed, Felicity Luard, Samuel Leuenberger, Gregorio Magnagni, Francis McKee, M & C Designers Ltd, Jessica Morgan, Tom Morton, Tim Mueller-Heidelberg, Gregor Muir, Neil Mulholland, Sarah Munro, Martin Myrone, Tim Neuger, Richard Noble, Josephine Pryde, Louise Ramsay, Burckhardt Riemschneider, Gary Rough, Catherine Schelbert, Andrea Schlieker, Michael Shamberg, Annushka Shani, Pia Simmig, Vivien Spencer, Alison Smith, Beatrice Steiner, Rochelle Steiner, Douglas Stewart, Rachel Tant, Chris Tosic, Debra Vilen, Jonathan Vyner and Piers Warner.

Beatrix Ruf

REVISED NARRATIONS

NARRATIONS

BEATRIX RUF

In the international cycle of exhibitions, triennials are curious hybrids. On the one hand, they represent a departure from the biennials that provide an update, within a specific local context, of current international output for an equally international audience, since they require a longer period of research and development. On the other hand, they follow each other in such rapid succession that they cannot provide the same detached, retrospective review of trends and directions in contemporary art as, say, *Documenta* and the *British Art Show*, which take place every five years, or the presentations of the *Sculpture Project in Münster*, which are a full decade apart. The *Tate Triennial* is, moreover, a very recent newcomer to this genre of exhibition, still establishing its identity as a showcase for British art, the first instalment, *Intelligence*, having been held in 2000, and the second, *Days Like These*, in 2003.

However, because the *Tate Triennial* is held by an art institution that is actively involved in collecting, it has the great advantage of being able to reflect, at regular intervals, on the concerns and conditions of current art production, especially trends in Britain. Tate also has the benefit of being able to present the exhibition within the larger context of the museum's own collection, which provides a constant source for the reinterpretation, reiteration and reconsideration of earlier works.

This sits particularly well with the main focus of the approach taken by many of the artists in this exhibition. For in current art production there is a distinct tendency towards the reusing or recasting of cultural materials, whether from art history, film, music, architecture and design, or from theoretical and socio-political domains. Such an approach encompasses painting, sculpture, photography, drawing and performance. This *Tate Triennial* has therefore been configured around the themes of appropriation and repetition. While these are well-recognised strategies most commonly associated with postmodernism, the *Tate Triennial* identifies a significant reinvigoration and transformation of such processes in current practice. Artists today are forging new ways of making sense of reality, reworking ideas of authenticity, directness and social relevance, looking again into art practices that emerged in the previous century. We have invited artists representing several generations – including Peter Doig, Douglas Gordon and Liam Gillick, who participated in the previous two triennials – to partake in the exhibition, all of whom explore these themes in one way or another and whose work we regard as providing important points of reference for the younger generation.

However, this does not mean that a linear arrangement underlies the exhibition. On the contrary, the various approaches to the use of reference material can be detected across the different generations of artists represented in the show. The subjective and formal explorations of the older artists, and their transformation of existing imagery, forge a link with many of the younger participants. Ian Hamilton Finlay's layering of philosophical ideas, cultural and classical forms with the re-politicising of images, for example, has certain affinities with the works of, say, Michael Fullerton (who paints contemporary figures in the style of Thomas Gainsborough), and even with the remix of images, topics and practices in the installations, objects, films and performances of Cerith Wyn Evans. John Stezaker's serial collages, aimed at a 'reparation' of modernist deconstructions, create points of reference with the all-inclusive, anti-hierarchical works of Djordje Ozbolt, or with Luke Fowler's use of archive material to explore the history of the English composer Cornelius Cardew's Scratch Orchestra. Peter Doig's paintings – constructed from a mixture of his own photographs, found images and references from art history, film and popular culture – can be linked to and contrasted with the reactivation of romanticism in Christopher Orr's bleak and barren renditions of the sublime. By transferring her radical exploration of production conditions in the porn industry

to the context of art, Cosey Fanni Tutti shows numerous affinities with the inherently critical parallel activities of such artists as Liam Gillick and Lucy McKenzie. The latter borrows democratically from any number of sources to find new forms of representation, while Gillick's radical fictionalisation of historical facts points towards a renewed political awareness in artistic practice. In Muzi Quawson's photographic documentation of a family in Woodstock, meanwhile, historical 'reality' itself is shown to be a form of fictionalisation. And in addition to these inter-referential loops and repetitions, another form of repetition constitutes an important aspect: the revisiting of an artist's own works. In his installation and related performance, for example, Marc Camille Chaimowicz brings works first made in the 1970s partly into the present tense by inserting new elements in combination with slides and photographs documenting that past.

Of course, repetition is not in itself new to art history, or to cultural practice in general. Its forms have ranged from the classic reiteration of motifs, on a spectrum between tribute and pastiche; from collage, montage and appropriation to sampling, file-sharing, morphing and digital reproduction. No less varied than the types of repetition themselves are the ways in which they have been applied as strategies throughout the course of art history. These approaches may take the form of highlighting existing codes or revealing the innate artifice of a work in order to deconstruct or demystify it as an object. They may be used as a counterpoint to subjective formulations, as a form of de-identification and thus of critical praxis, as a subversion of power structures, or as a critique of institutions and the conditions under which art and culture are produced. They may also be used as a multiplication or extension of self-identity.

Many of the artists in *Tate Triennial* combine visual codes and imagery from competing rather than connecting sources. Rebecca Warren, for example, draws from a variety of influences, ranging from Edgar Degas to Helmut Newton and Robert Crumb, to create roughly-modelled clay figures that explore our understanding of the figurative ideal. Nicole Wermers similarly adopts a combination of styles to create her hybrid forms. In the work of Enrico David, Daria Martin and Alan Michael, many historical versions of repetition have been reactivated in the sense that they have been reloaded with topical narratives and ways of reading. This occurs within a diverse conceptual framework that often employs not just one aspect of repetition but several. David's practice, for example, encompasses traditional artistic media such as bronze casting or painting in tandem with craft practices such as marquetry, book-binding or the design of a printed silk scarf, while Martin refers to Russian Constructivism and the works of Oskar Schlemmer and Sonia Delauney. Michael's borrowings move without constraint between different painting styles, contemporary film and the world of fashion. These appropriated forms are adapted into a personal vocabulary that both reflects and differs from traditional techniques.

All of this begs the question as to whether these current strategies of repetition constitute a nostalgic look back to the ideas of early modernism, or if they have more in common with postmodern theories and the aesthetics of appropriation that emerged at the end of the twentieth century. It may be, for example, that the interest in spiritualism, romanticism and counter-cultures exhibited by artists like Orr in his melancholy landscape paintings, or Olivia Plender in her revisitation of nineteenth-century spiritualism, can be seen as a bid to take up where the unfinished revolutionary projects of modernism and the social utopias of the early twentieth century left off. The cross-pollination of the formal syntax of modernism engaged by David, Ryan Gander, or Eva Rothschild in her elemental abstract sculptures, could be seen in a similar light. Or it may be that the strategies adopted by artists

such as Cosey Fanni Tutti, Gander's self-referential commentary, or Tino Sehgal's insertion of actors into the gallery, can be considered part of the tradition aimed at a revision or transformation of given structures, such as the institutional critiques of the 1980 and 1990s. Angela Bulloch's use of forms and narratives from different fields such as art, film and design, certainly subverts systems of order and control, investing them with a poetic lyricism while at the same time exposing how society is constructed and regulated.

In an important sense, however, neither theory is applicable. For what seems clear is that the approaches to reference, appropriation and revision that informed twentieth-century art are now being constructively applied to the present-day situation in a way that is as distinct from pastiche or tribute as it is from collage and montage and even from postmodernist quotation. The artists in this exhibition are not merely wallowing in a withdrawal into the realm of the personal, the subjective and the retro-loving. Nor are they indulging in a collective show of earnestness that does little more than pay lip-service to issues surrounding today's chaotic and global political climate. Influenced by the transformation of society and daily life in general, they are offering new and different models for serious social and political engagement.

Since these new strategies of repetition weave a fabric in which the art form can no longer be easily distinguished from reality, nor filtered communication differentiated from authenticity, artistic approaches that critique the difference between media, reality and systems of reference may now be obsolete. Hence, in dealing with the world's many and diverse interfaces, artists are deploying repetition as a tool, rather than as a finished product. What is undergoing revision here is not the object itself, but the way in which it is interpreted – with all the concomitant ideals, utopias and meanings.

In a publication on the American artist Sturtevant, whose replicas of classic modern artworks make her one of the most radical exponents of repetition, Udo Kittelman neatly encapsulates the approach taken by the artists in this exhibition. 'The brutal truth of the work is that it is not copy [sic].'[1] She uses originals, he writes, 'as a source and a catalyst ... to expand and develop our current notions of aesthetics ... and open space for new thinking.'[2] As the philosopher Søren Kierkegaard expressed it in his work *Repetition* of 1843: 'that which is repeated has been – otherwise it would not be repeated – but the very fact that it has been makes the repetition something new.'[3] He also pointed out that 'If one does not have the category of recollection or of repetition, all life dissolves into an empty, meaningless noise.'[4] The work in the *Tate Triennial* is not about making postmodern gestures of irony, wit or caricature; it is about finding new narratives within hegemonic codes and inventing fresh meanings within the noise of modern life.

Beatrix Ruf
Translation: flett-schelbert

APROPOS

APPROPRIATION

WHY STEALING IMAGES TODAY FEELS DIFFERENT

JAN VERWOERT

1. The historic momentum of appropriation, in the 1980s and today

Appropriation is a common technique. People appropriate when they make things their own and integrate them into their way of life, by buying or stealing commodities, acquiring knowledge, claiming places and so on. Artists appropriate when they adopt imagery, concepts and ways of making art that other artists have used previously, adapting these artistic means to their own interests. They also do so when they take objects, images or practices from popular (or foreign) cultures and restage them within the context of their own work either to enrich or erode conventional definitions of what an artwork can be. As such, this technique is comparatively timeless, or at least, it has been practised for as long as modern society has existed. For, ever since labour was divided into an abstract social organisation that alienated people from ideal ways of life, appropriation has been a practice of getting back from society what it has taken from its members.

At the same time, appropriation can be understood as one of the most basic procedures of modern art production and education. To cite, copy and modify exemplary works from art history is the model for developing the art practice that (neo)classicist tendencies have always championed. During the last two centuries this model has been repeatedly challenged by advocates of the belief that modern individuals should produce radically new art by virtue of their spontaneous creativity. The postmodern critics of this cult of individual genius in turn claimed that it is a gross ideological distortion to portray the making of art as a heroic act of original creation. Instead they advanced the paradigm of appropriation as a materialist model that describes art production as the gradual reshuffling of a basic set of cultural terms through their strategical reuse and eventual transformation.

Such a general account of appropriation as a common social strategy and basic artistic operation may help to outline some of the overall implications of the concept. What it cannot capture, however, is the specific momentum that gives the debates about appropriation their particular focus and urgency in different historical situations. It might appear futile to attempt to reconstruct the exact spirit of the moment in the late 1970s when the notion of appropriation emerged in critical discourse alongside the concept of postmodernism to become one of the key contested terms in the debates of the 1980s. But to try to picture the historic momentum of this discourse seems crucial, because there is evidence that the situation today has significantly changed. To practice and discuss appropriation in the present moment means something different from before, and to bring out this specific difference it seems necessary to grasp what was at stake in the late 1970s for a better understanding of what, by contrast, is at stake now.

The cultural experience that the discourse of appropriation conveys under the sign of postmodernity is that of a radical temporal incision. It is the experience of the sudden death of modernism and the momentary suspension of historical continuity. The stalemate situation of the Cold War seemed to bring modern history to a standstill, freezing the forces of progress. These frozen lumps of dead historical time became the objects of artistic appropriation. Robert Longo, for example, appropriated figures of movie actors cut from freeze frames, with their movements suspended in mid-air and bodies arrested in the momentary poses they happened to assume when the film was stopped. Cindy Sherman appropriated the visual language of epic Hollywood cinema to halt and arrest the motion of the moving pictures in isolated still images of female figures locked in a spatial mise-en-scène in which the timeline had gone missing. These works convey an intense sense of an interruption of temporal continuity, a blackout of historical time that mortifies culture and turns its tropes into inanimate figures, into pre-objectified, commodified visual material, ready to pick up and use.

Now, imagine the reels of the projectors suddenly begin to start spinning again, the freeze-frame dissolves into motion and Longo's suspended figures crash to the ground as the pain of the blow they received from their invisible opponent registers and propels them forward. Sherman's heroines unwind, begin to speak and confess their story to the camera. You could say that this is what happened after 1989. When the superpowers could no longer hold their breath and the Wall was blown down, history sprang to life again. The rigid bipolar order that had held it in a deadlock dissolved, releasing a multitude of subjects with a visa to travel across formerly closed borders and with unheard histories to tell. Their testimonies went straight down on digital videotape. The dead elegance of the Cibachrome print was replaced by the live look of real-time video footage as the signature aesthetic of the new decade. The Cold War had frozen time and mapped it in space as it fixed the historical situation after World War II for over four decades in the form of a territorial order of rigid geopolitical frontiers. It is from this map that a multitude of asynchronous temporalities now begin to emerge along the faultlines drawn by the geopolitical regimes of modernity. Wars erupt over territories that were shaped on the drawing-room tables around which the emerging world powers gathered to divide the globe among themselves. While some countries anticipate a global future by simulating the arrival of the information age, the outsourcing of manual labour from these countries forces other societies back in history to the time of exploitation evinced by early industrialisation. In many countries, including possibly the US, social life is organised by means of two governmental technologies that should exclude, but in fact reinforce each other: the modern secular state and pre-modern theocracy. Religion, a force that was thought to be crushed and buried under the profanities of capitalism and atheist doctrines of socialism, has resurfaced as a thing of the past that shapes the present.

If we accept this sketchy account as a preliminary description of the current historical condition, it becomes clear that a key difference between the situation at the end of the 1970s and today is that the axes of space and time have shifted into a different angle in relation to each other. The standstill of history at the height of the Cold War had, in a sense, collapsed the temporal axis and narrowed the historical horizon to the timeless presence of material culture, a presence that was exacerbated by the imminent prospect that the bomb could wipe everything out at any time. To appropriate the fetishes of material culture, then, is like looting empty shops on the eve of destruction. It's the final party before doomsday. Today, on the contrary, the temporal axis has sprung up again, but this time a whole series of temporal axes cross global space at irregular intervals. Historical time is again of the essence, but this historical time is not the linear and unified timeline of steady progress imagined by modernity; it is a multitude of competing and overlapping temporalities born from the local conflicts that the unresolved predicaments of the modern regimes of power still produce. The political space of the globe is mapped on a surreal texture of criss-crossing timelines.[1] The challenge of the moment is therefore to rethink the meaning of appropriation in relation to a reality constituted by a multiplicity of spatialised temporalities. The point of departure for such considerations – and also the reason why appropriation remains relevant as a critical (art) practice – is the undiminished if not increased power of capitalist commodity culture to determine the shape of our daily reality. The force that underlies the belief in the potential of appropriation is the hope that it should be possible to cut a slice out of the substance of this commodity culture to expose the structures that shape it in all their layers. It is also the hope that this cut might, at least partially, free that slice of material culture from the grip of its dominant logic and put it at the disposal of a different use. The practical question is, then, where the cut must be applied on the body of commodity culture and how deep it must

go to carve out a chunk of material that shows the different temporalities overlying each other like strata in the thick skin of the commodity's surface.

The object of appropriation in this sense must today be made to speak not only of its place within the structural order of the present material culture but also of the different times it inhabits and the different historical vectors that cross it. So there is a positive hope that the exhibition of the appropriated object could today still create this sudden moment of insight that we have known it can produce ever since Duchamp put a bottle dryer on display in a museum, namely that it could show what (in a particular social context at a specific historical moment) it means for something to mean something. So we trust the appropriated object to be able to reveal in and through itself the historical relations and dynamics that today determine what things mean.

But we should perhaps be less optimistic about the possibility of thinking of the object of appropriation and the knowledge it generates in terms of property. If one maps the act of appropriation solely on a structural topography of social *space* there is little room for ambiguity concerning issues of property. In the moment of its expropriation the object is taken away (bought, stolen or sampled) from one place and put to use in another. There may be quarrels over copyright and property-rights violations, but they occur precisely because it is generally possible to trace where the object was taken from and where it is now, whose property it was and who took it to make it a part of his or her life, art, music and so on. Property is an issue because the position of the appropriated item can clearly be fixed. If, however, you try to fix the position of the object of appropriation in *time* and draw the trajectory of its displacement in a co-ordinate system with multiple temporal axes, it obviously becomes more complicated. How would you clarify the status of ownership of something that inhabits different times, that travels through time and repeats itself in unpredictable intervals, like for instance, a recurring style in fashion, a folkloristic symbol that is revived by a new political movement to articulate its revisionist version of a country's history, or a complex of second-rate modernist architecture occupied by residents who know nothing of its original designs but still have to find a way of living with the ghosts that haunt the building? Who owns a recurring style, a collective symbol or a haunted house? Even if you appropriate them, they can never be entirely your private property. Dead objects can circulate in space and change their owners. Things that live throughout time cannot, in any unambiguous sense, pass into someone's possession. For this reason they must be approached in a different way. Tactically speaking, the one who seeks to appropriate such temporally layered objects with critical intent – that is, with an attitude that differs significantly from the blunt revisionism of neo- (or 'turbo'-) folkloristic exploitations of the past – must be prepared to relinquish the claim to full possession, loosen the grip on the object and call it forth, invoke it rather than seize it.

2. From allegory to invocation

Thus the specific difference between the momentum of appropriation in the 1980s and today lies in a decisive shift in the relation to the object of appropriation – from the reuse of a dead commodity fetish to the invocation of something that lives through time – and, underlying this shift, a radical transformation of the experience of the historical situation, from a feeling of a general loss of historicity to a current sense of an excessive presence of history, a shift from not enough to too much history, or rather, too many histories. To bring out this difference more clearly, the steps of this argument can be retraced, starting over from the beginning by calling up some of the theoretical concepts that gave appropriation

a specific meaning in the American art-critical discourse of the late 1970s and early 1980s, in order to develop some contemporary reformulations of these ideas.

If you compare, for instance, the writings of Douglas Crimp, Frederic Jameson and Craig Owens on the subject of appropriation, you will find a common motif in these texts. It is the idea that the sudden dissolution of historical continuity charges postmodern material culture with an intense sense of a presence without historical meaning – and that this intensity can be isolated in the object of appropriation as it manifests the breakdown of signification by exposing the empty loop in which the means to make meaning are spinning in and around themselves. In arguably the most beautiful lines of his essay 'Pictures' (1979) Crimp, for instance, evokes the feeling of being spellbound by the silence of appropriated images, by their insistence on remaining mute and foreclosing historical narratives. He describes the experience of these pictures as marked by 'the duration of a fascinated, perplexed gaze, whose desire is that they disclose their secrets; but the result is only to make the pictures all the more picturelike, to fix forever in an elegant object our distance from the history that produced these images. That distance is all that these pictures signify'.[2] A similar moment of melancholy, an acknowledgement of the impossibility of grasping history in its images, makes itself felt in the admission made by Jameson in his essay 'Postmodernism and Consumer Society' (1982) that 'we seem condemned to seek the historical past through our own pop images and stereotypes about the past, which itself remains forever out of reach.'[3] All we can do, Jameson concludes, since the historical depth of the signs we have at our hands is irreversibly voided, is 'to imitate dead styles, to speak through the masks and with the voices of the styles in the imaginary museum'.[4]

This idea of art as a form of 'speech in a dead language' (as Jameson defines pastiche)[5] is further refined by Craig Owens in his essay 'The Allegorical Impulse: Toward a Theory of Postmodernism' (1980),[6] where he frames speaking a dead language, or rather speaking a language that testifies to the death or dying of its historical meaning, as the language of allegory. Owens summarises Walter Benjamin's account of why, in German baroque drama, allegory became the predominant mode of articulating a sense of culture in decay, writing that 'from the will to preserve the traces of something that was dead, or about to die, emerged allegory'.[7] By analogy Owens infers that the historical momentum of postmodernity, as the modern baroque, lies in the potential to use allegory as a rhetorical form that can capture the experience of the present where the historical language of modernism is dead and in ruins. He understands allegory as a composite sign made up of a cluster of dead symbols that are collaged together to create a shabby composition, a signifier in ruins that exposes the ruin of signification. By defining allegory as a collage of appropriated imagery, Owens in reverse characterises contemporary art practices of appropriation as producing allegories of the present ruinous state of the historic language of modern art.

The melancholy exercise of speaking or contemplating a dead language in the moment of its allegorical appropriation, however, also delivers a particular kick. Crimp analyses the practice of working with appropriated images as driven by the fetishistic or morbid joy deriving from the devotion to an opaque artefact: 'Such an elaborate manipulation of the image does not really transform it; it fetishizes it. The picture is an object of desire, the desire for the signification that is known to be absent.'[8] Jameson draws on another form of neurotic pleasure to describe the intensity of experiencing the breakdown of signification in the moment of encountering the isolated object of appropriation. He uses schizophrenia as a model to outline the postmodern condition of historical experience. According to Jameson, schizophrenia implies a loss of the mental capacity to perceive time as ongoing

in a consistent order, which results in the inability to organise experiences in coherent sequences that would allow them to make sense, which in turn generates a heightened sense of the visceral and material presence of the isolated fragments of perception. He writes that 'as temporal continuities break down, the experience of the present becomes powerfully, overwhelmingly vivid and "material": the world comes before the schizophrenic with heightened intensity, bearing a mysterious and oppressive charge of affect, glowing with hallucinatory energy.'[9] Like Crimp, Jameson frames a symptomatic moment in which the individual experiences the breakdown of historical interpretation in the face of an opaque artefact as an ambivalent sensation of depression and ecstasy. So, what for Jameson is the quintessential postmodern experience is for Crimp the particular kick that appropriation art delivers.

All of these thoughts revolve around an experience of death, the certain death of modernity and the sense of history it implied, an experience of death that is framed and fixed by the object of appropriation through the accumulation of the dead matter of hollowed-out signs in the form of allegory, the ruin of language. That these terms sound like the vocabulary of Gothic novels is certainly no coincidence, since the invocation of a sense of gloom seems to have been a key moment in the discourse of postmodernism. It is, however, a Gothic novel written in denial of the implications of the atmosphere it conjures up, namely the suspicion that the dead might actually not be as dead as they are declared to be and that they might return as revenants to walk among the living. Through its relentless repetition, the evocation of the emptiness of the signifier and the death of historical meaning comes to sound like a mantra, a spell to keep away the spectres of modern history that linger on the margins of the postmodern discourse. The re-emergence of a multiplicity of histories in the moment of the 1990s, then, resembles the return of these ghosts to the centre of the discourse and equals the sudden realisation that the signs speak as multiple echoes of historic meaning that begin to reverberate in their hollow body – the insight that what was deemed dead speech has indeed manifest effects on the lives of the living.

This shock of the unsuspected return of meaning to the arbitrary sign is pictured in the climactic scene of Edgar Allen Poe's *The Fall of the House of Usher* (1839). On a stormy night, the narrator recounts, he tried to comfort and calm his host, the lord of the house of Usher, who is plagued by nervous hypersensitivity and an imminent sense of anxiety, by reading a fanciful chivalrous romance to him. Instead of distracting the attention from the surrounding reality, however, the words of the story are in fact answered by immediate echoes in the real world:

> At the termination of this sentence I started, and for a moment paused;
> for it appeared to me (although I at once concluded that my excited
> fancy had deceived me) – it appeared to me that, from some very remote
> portion of the mansion, there came, indistinctly, to my ears, what might
> have been, in its exact similarity of character, the echo (but a stifled
> and dull one certainly) of the very cracking and ripping sound which
> Sir Launcelot had so particularly described.[10]

It turns out that the literary account of a knight breaking into a dragon's lair is step by step echoed in the real world by the literal procedure of the undead twin sister of the Count of Usher breaking out of the tomb in which she was buried alive to come and take her brother to the shadows with her. It is this sudden realisation that words and images, as arbitrarily construed they may be, produce unsuspected effects and affects in the real world that could be said to mark the momentum of the 1990s. A key consequence of this momentum

is the shift in the critical discourse away from a primary focus on the arbitrary and constructed character of the linguistic sign towards a desire to understand the *performativity* of language and grasp precisely how things are done with words, that is, how language through its power of injunction enforces the meaning of what it spells out and, like a spell placed on a person, binds that person to execute what it commands.

In the light of this understanding the aim of appropriation can no longer be analysis alone, quite simply because the effects of staging an object of appropriation can no longer be contained in a moment of mere contemplation. When you call up a spectre, it will not content itself with being inspected, it will require active negotiations to accommodate the ghost and direct its actions or at least keep them in check. By the same token, if we understand the evocation of a concept, image or object in the moment of its appropriation and exhibition to have manifest and potentially unsuspected effects on the real world, to isolate, display and, as it were, fix this concept, image or object in the abstract space of pure analysis is no longer enough. To acknowledge the performative dimension of language means to understand the responsibility that comes with speaking, to engage in the procedures of speech and face the consequences of what is being said. To utter words for the sake of analysis already means to put these words to work. You cannot test a spell. To utter it is to put it into effect. In this sense an art of appropriation understood as invocation must concern itself even more with the practicalities and material gestures that are performed in the ceremony of invocation. This concern for practicalities simultaneously raises the question: 'To what ends is the ceremony performed?' That is: with what consequences is the object of appropriation put to its new use? This is a question of practical ethics: with what attitude should appropriation be practised? Would it be acceptable for a critical art practice to give in to the power of the performative alone and invoke the ghosts of historic visual languages to command them to work for the interests of the living?

There is ample evidence that this is precisely what current public-address experts do. Every orchestrated retro-trend or revisionist resurrection of nationalist histories sees hordes of ghosts pressed into the service of the market and other ideological programmes. So, to resist the urge to master the ghosts by programming the effects of appropriation seems a better alternative. This is always assuming that it is actually possible to master ghosts, while the uncanny quality of an encounter with them after all lies precisely in the fact that in the relationship with a spectre and the one who invokes it, who controls whom will always remain dangerously ambiguous and the subject of practical struggle. This brings us back to the questionable status of property in the act of appropriation discussed before. If through appropriation one seeks to (re-)possess an object, what if that object had a history and thus a life of its own? Would the desire for possession then not inevitably be confronted by a force within that object that resists this very desire? In his book *Spectres of Marx* (1994) Derrida describes this moment of ambiguity and struggle as follows:

> One must have the ghost's hide and to do that, one must have it. To have it, one must see it, situate it, identify it. One must possess it without letting oneself be possessed by it, without being possessed of it ... But does not a spectre consist, to the extent that it consists, in forbidding or blurring this distinction? In consisting in this very undiscernability? Is not to possess a spectre to be possessed by it, possessed period? To capture it, is that not to be captivated by it?[11]

On the grounds of this observation, that the relation between the ghost and the one who invokes it will remain in a precarious state of limbo, Derrida then develops an ethics,

that is, he formulates the task of finding ways of practically approaching and doing things with ghosts that would do justice to the complex nature of their presence and relation to us. The task is to 'learn to live *with* ghosts'[12] and this means to learn 'how to let them speak or how to give them back speech'[13] by approaching them in a determined way that still remains undetermined enough to allow them to present themselves:

> To exorcise not in order to chase away the ghosts, but this time to grant them the right, if it means making them come back alive, as *revenants* who could no longer be *revenants*, but as other arrivants to whom a hospitable memory or promise must offer welcome – without certainty, ever, that they present themselves as such. Not in order to grant them the right in this sense but out of a concern for *justice*.[14]

It seems that this ethical maxim could equally serve as a practical guide to appropriation today. If we assume that the horizon of our current historical experience is defined by the ambiguous influences and latent presence of the unresolved histories, the ghosts, of modernity, then an act of appropriation that seeks to show what it means for something to mean something today must expose these unresolved moments of latent presence as they are, and that means first of all not to suggest their resolution in the moment of their exhibition. Appropriation, then, is about performing the unresolved by staging objects, images or allegories that invoke the ghosts of unclosed histories in a way that allows them to appear as ghosts and reveal the nature of the ambiguous presence. And to do that is first of all a question of finding appropriate ways of going through the practicalities of the performance of evocation, that is: a question of practice.

Jan Verwoert

PABLO BRONSTEIN	IAN HAMILTON FINLAY
ANGELA BULLOCH	LUKE FOWLER
GERARD BYRNE	MICHAEL FULLERTON
MARC CAMILLE CHAIMOWICZ	RYAN GANDER
LALI CHETWYND	LIAM GILLICK
COSEY FANNI TUTTI	DOUGLAS GORDON
ENRICO DAVID	MARK LECKEY
PETER DOIG	LINDER
KAYE DONACHIE	LUCY McKENZIE

DARIA MARTIN	OLIVIA PLENDER
SIMON MARTIN	MUZI QUAWSON
ALAN MICHAEL	EVA ROTHSCHILD
JONATHAN MONK	TINO SEHGAL
SCOTT MYLES	JOHN STEZAKER
CHRISTOPHER ORR	REBECCA WARREN
THE OTOLITH GROUP	NICOLE WERMERS
DJORDJE OZBOLT	CERITH WYN EVANS
OLIVER PAYNE and NICK RELPH	

PABLO BRONSTEIN

Pablo Bronstein's drawings, architectural structures and performances investigate Baroque ideas of theatricality, artificiality and *trompe l'oeil*, making them visible in the present. Rather than positing any straightforward equivalence between seventeenth-century ideas of the 'world as a stage' and the experience of living in a complex and densely populated twenty-first-century city, Bronstein's work is concerned with the decorative aspects of Baroque as diversion or delusion. His ink drawings of elaborate architectural fancies and stage-sets are rendered in the style of the seventeenth-century Bibiena family, also borrowing elements from the designs of James Stirling or Aldo Rossi, who adapted and abbreviated those styles. Deliberately conservative, the drawings are reinventions, generating new designs from the historical source material. But Bronstein does not unpick the historical style in order to isolate elements and create a new analytic language. Rather, he makes his finely detailed impressions as though his consciousness as an artist has collapsed into that historical moment, dislodged from the present: as if he is 'inhabited' or possessed by the past. The drawings' forms – spirals, cornices, fluted columns, arches – seem to work their way with increasing fluidity through his pen. The performative nature of these drawings is carried through into his architectural 'modella' – rudimentary stage sets – and live performances, both of which inject pedestrian movement with aesthetic flourishes.

Bronstein's yellow-grey plaza space made for the Institute of Contemporary Arts, London in *Six Easy Steps, Concept for a Public Square* August 2005 was designed to squeeze out the majority of the neutral gallery space, marking out an awkward boundary around which viewers were forced to negotiate. Its decoration with reduced architectural motifs in combination with its role as physical barrier allowed it to function doubly as stage-set

Born in 1977
in Buenos Aires

2002–2004
Goldsmiths College,
University of London

1998–2001
The Slade School of Fine Art,
UCL, London

Selected Solo Exhibitions

2006
Herald St, London

Selected Group Exhibitions

2006
Becks Futures, ICA, London

Scene 1, Mary Boone Gallery,
New York

2005
London in Six Easy Steps,
ICA, London

Publish and Be Damned,
London (publishing fair
in the Crypt of St. James,
Clerkenwell Green)

Modified Uniforms, Blum
and Poe, Los Angeles

2004
In the Palace at 4am, Alison
Jacques Gallery, London

Lives and works in London

and as a disruption of real space, framing the viewer's presence as a part of its fiction. In this piece and previous works such as *Perspectival Structure* 2005 at the Cooper Gallery, Duncan of Jordanstone College of Art and Design, Dundee, Bronstein's interest in the historical adoption of mannered movement as an extension of architectural and interior design, such as the seventeenth-century courtly etiquette of Sprezzaturra, is filtered through the language of contemporary public space. For the *Triennial* Bronstein will collaborate with architect Celine Condorelli to design a theatrical stage and seating structure for use in the daytime as a 'plaza' space on selected evenings for performance events.

Pictorial and real space merge in Bronstein's work to an extreme degree, from the private but self-conscious act of the artist drawing in his studio to the way in which his theatrical structures falsify the logic of the white cube. Drawing on the everyday function of the north Duveen gallery space as a key navigational axis in the visitor's path around the building, Bronstein's performance for the *Triennial* serves as a disruption and elaboration of this activity. Working with a group of Baroque dance enthusiasts, he combines the historical form with 1960s Minimalist choreography, convoluting the practice of straightforward walking to make the mannered swirls and turns of a complex, ritual *pas-de-deux*. This quiet, minimal disruption of mobile bodies engaged in their ordinary movement through the gallery acts as a kind of fold in habitual ways of behaving. Bronstein's performance subverts the logic of pedestrian movement as a form of efficient progress from A to B to make it wasteful and beautiful.

Catherine Wood

Pablo Bronstein
*Large Building
with Courtyard* 2005
Ink on paper. 41 x 47.5
Courtesy the artist and
Herald St. London

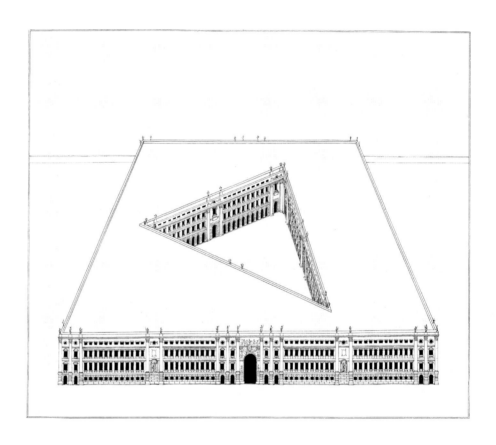

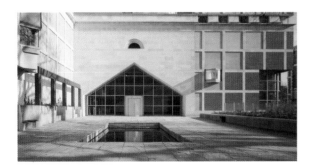

1

ANGELA BULLOCH

The starting point for Angela Bulloch's varied practice is often a system that informs how society is constructed and regulated. Through extracting structures or forms from the everyday world she exposes the authority of their regulatory function. Since 2000, she has been manipulating the way in which real and fictional narratives are constructed, taking scenes from iconic films such as Michelangelo Antonioni's *Blow Up* (*Blow-Up TV* 2000) and *Zabriskie Point* (*Z-Point* 2001) or television news coverage (*Macro World: One Hour 3 and Canned* 2002), and dismantling them pictorially. Together with Holger Friese, she developed a modular light system that uses fluorescent tubes to illuminate immaculately constructed glass-fronted plywood units, allowing over sixteen million colours to be displayed. These 'pixel boxes' are assembled to form towers, rows or even entire 'movie screens' that amalgamate the cool aesthetic of Minimalist sculpture with the look of 1970s hi-fi design. The reduced visual information is slowed down and presented as three-dimensional light works that are essentially abstract, yet capture the mood of the original source. The intensity of these constantly pulsing boxes is hypnotic; their ethereal presence commands the space and the sensory response of the viewer, an effect often heightened by a corresponding soundtrack that is similarly abstracted from a borrowed source.

In *Disenchanted Forest X 1001*, first shown in Berlin in 2005, Bulloch utilises sound and light to create a complex and at times disorientating installation. She comments, 'I'm making a kind of hermetic artwork and the very act of doing that is a political act in itself. There are many references and complexities to the work that form its entirety.'[1] At its centre are a stage-like platform and a suspended ceiling that pivot against each other and are connected by luminescent string, just over a kilometre in length. A reference to Marcel

Born in **1966**
in Rainy River, Canada

1985–1988
Goldsmiths College,
University of London

Selected Solo Exhibitions
2005
Modern Art, Oxford
Secession, Vienna
2004
Antimatter, Eva
Presenhulber, Zurich
2002
Institute of Visual Culture,
Cambridge
2001
Kunsthaus Glarus,
Switzerland

Selected Group Exhibitions
2005
*Preis der Nationalgalerie
für Junge Kunst*, Hamburger
Bahnhof, Berlin
2003
*Utopia Station: Dreams and
Conflicts – The Dictatorship
of the Viewer*, 50th Venice
Biennale
2002
Remix, Tate Liverpool,
Liverpool
1996
Life / Live, Musée d'Art
Moderne de la Ville de Paris,
Paris
1988
Freeze Part I, PLA Building,
Docklands, London

Lives and works in Berlin

Duchamp's *Sixteen Miles of String*, installed at the Surrealist exhibition of 1942 in New York, this web of woven light simultaneously makes the space visible while obstructing access to it. Screen-printed posters that hang on the wall and lie in a stack pay homage to other art-historical precedents such as Op art and the work of artists Adolf Luther and Felix Gonzalez-Torres. The 1,001 numbered metal disks that hang in a line around the wall allude to the numbering system given to trees managed by Berlin's environmental agency. A spotlight pinpoints numbers at random, which together with the changing lights and electronic music composed by Florian Hecker, creates a phenomenological experience reminiscent of a club situation, while evoking the sensation of living within a controlled climate of constant technological surveillance. A less specific reference for *Disenchanted Forest X 1001* is the Surrealists' use of the forest (a potent symbol in German culture) as a metaphor for the imagination. For Max Ernst, this fascination resulted from his boyhood feelings of enchantment and terror with local woods, a dark, magical allure that is updated by Bulloch to create an artwork that relies on, yet challenges, its institutional context, and which unites formal perception with a multi-referential conceptual proposition.

Katharine Stout

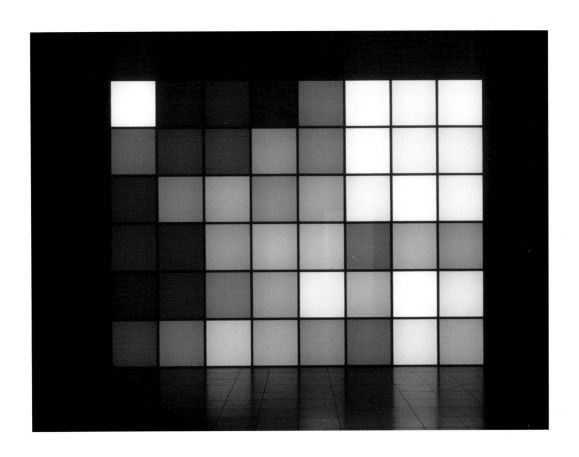

Angela Bulloch
Z-Point **2001**
48 DMX Modules, sound
system, duration 8 min
13 second loop
300 x 400 x 55
Each module 50 x 50 x 50
Installation at Kunsthaus
Glarus, 2001
Courtesy Städtische Galerie
im Lenbachhaus, Munich.
Permanent loan from
private collection

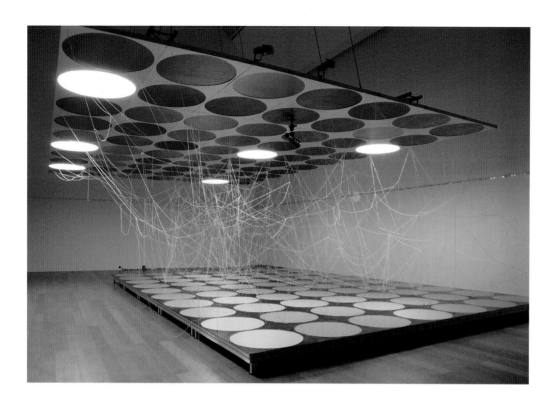

Angela Bulloch
Disenchanted Forest X 1001
2005
Mixed media. Ceiling
and floor both 800 x 560
Installation at Hamburger
Bahnhof, Museum für
Gegenwurst, Berlin, 2005
Collection Helga de Alvear, Madrid

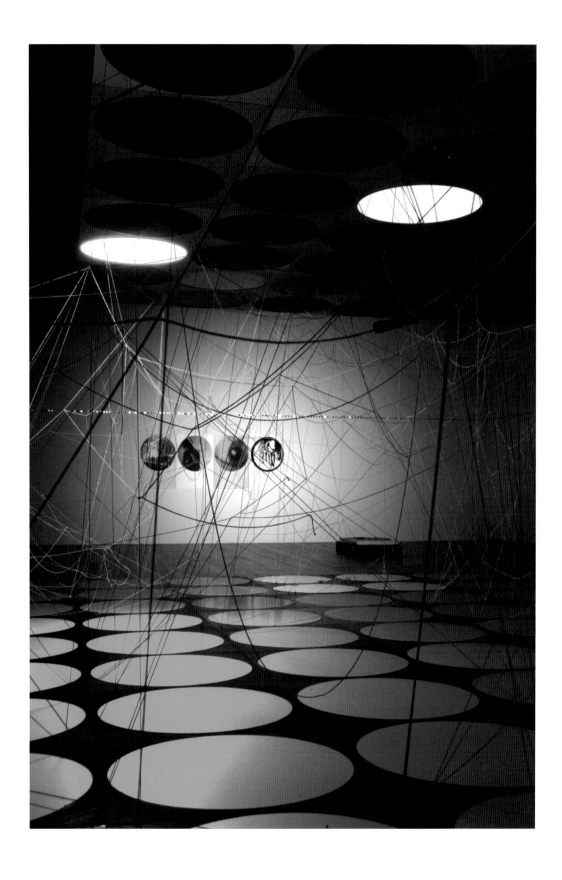

Angela Bulloch
Disenchanted Forest X 1001
2005
Mixed media. Ceiling and
floor both 800 x 560
Installation at Hamburger
Bahnhof, Museum für
Gegenwurst, Berlin, 2005
Collection Helga de Alvear, Madrid

GERARD BYRNE

Gerard Byrne's installation *New Sexual Lifestyles* 2003 takes as its basis a round-table discussion on the theme of 'emerging behaviour patterns, from open marriage to group sex' published in a 1973 edition of *Playboy* magazine. Byrne used the text as a found 'script' to stage a dialogue between actors, which he recorded on video. Casually dressed and relaxing in the lounge of the late modernist Goulding Summer House (1972), which Byrne has said could 'stand for, but not be mistaken for, the original site of discussion', the actors dramatise the permissive debate, exploring topics ranging from monogamy to bestiality and sado-masochism. With its combination of group shots, single shots and close-ups of the speakers, the film appears to be situated somewhere between a TV sitcom and a cultural discussion programme. Its curious atmosphere owes much to the gap between the language and attitudes – such as Al Goldstein's belief that he 'owns' his wife – evident in the heavily edited and thus mediated 1970s dialogue, intended for a weekly magazine, and the lucid immediacy of the technological capture of the present. While a television recording of a debate on the same topic made during the 1970s would signpost its historicity with a 'patina' of degraded visual effect and retro fashion, Byrne's invented staging destabilises our perceptions by subtly intervening in our ability to marry what we see with what we hear. Installed in the gallery alongside photographs depicting the original magazine transcript and images of the sleek, modern windows of the summer house, the piece is an exercise in transparency and opacity: rendering 'live' a once-progressive debate, and yet obscuring our access to its authentic origins with the substitution of contemporary bodies and voices.

Byrne's earlier work, why its time for *Imperial again ...* 1999, explored similar territory, staging for video a transcript of a conversation between Frank Sinatra and the chairman of Chrysler cars from the firm's 'advertorial' of 1981. Byrne's framing of what was intended to be read as an authentic 'man to man' conversation about the new car reveals the commercial construction of masculinity into which the consumer is invited literally to buy. Thus at a formal level, the way in which his work collapses past and present, fact and fiction, unpicks notions – challenged as 'patriarchal' by feminist theory – of linear history or narrative.

Through his photographs, videos, installations and, more recently, his live work, Byrne tests the contingent nature of different representational modes against each other by grafting them together. In the installation *In Repertory* 2004 at The Project in Dublin, visitors walked around what they believed to be contemporary sculptures but were in fact reconstructed elements from historical theatre sets such as *Oklahoma!* or *Waiting for Godot*. By setting up a fixed camera to film the visitors in the space, Byrne bracketed their role between a primary encounter with the sculptures and the enveloping fiction of the narrative plays. Exploring a similar theme in a different way, his photographs made of the set of *Waiting for Godot* claim to simulate the 'subjective' viewpoints of the play's characters, exposing the disparity between photography's empiricism and the suspension of disbelief at stake in our encounter with the 'world' of the theatre stage.

Catherine Wood

Born in **1969**
in Dublin

1999
Whitney Independent Study Program, New York

1997–1998
PS1 Contemporary Art Centre Program, New York

1996
New School for Social Research, New York

1991
National College of Art and Design, Dublin

Selected Solo Exhibitions

2005
Gerard Byrne, Void Gallery, Derry

2004
Hommes à Femmes, Green On Red Gallery, Dublin

In Repertory, Project Arts Centre, Dublin

2003
Gerard Byrne, Kunstverein, Frankfurt

Selected Group Exhibitions

2005
If I Can't Dance I Don't Want to be Part of Your Revolution, Den Bosch, Netherlands

I Really Should, Lisson Gallery, London

2003
8th Istanbul Biennial

2002
Manifesta 4, Frankfurt

Lives and works in Dublin

Gerard Byrne
New Sexual Lifestyles 2003
Detail of three-channel video
installation with photographs
Dimensions variable
Courtesy the artist and Green
on Red Gallery, Dublin

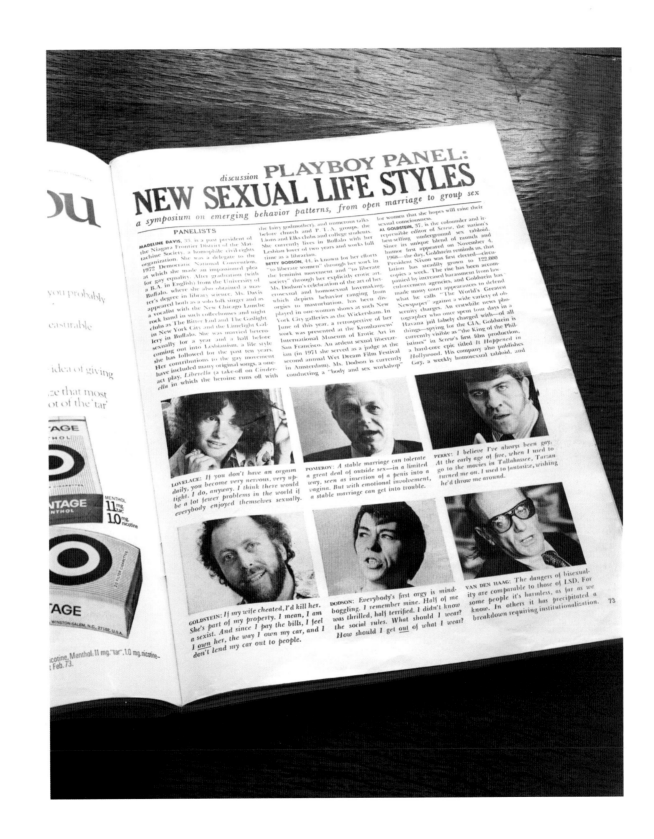

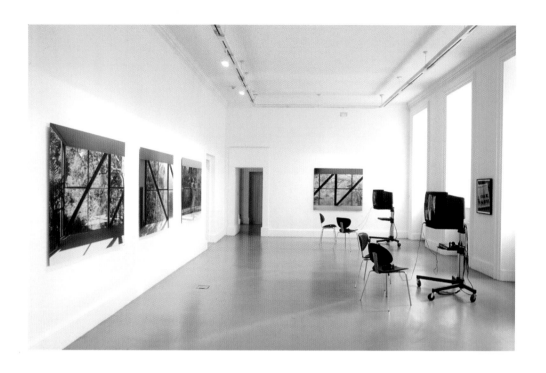

3

Gerard Byrne
New Sexual Lifestyles 2004
**Installation at Irish Museum
of Modern Art, Dublin, 2004**
Courtesy the artist and Green
on Red Gallery, Dublin

Gerard Byrne
In repertory 2004
**Detail of multi-phase project
including theatrical elements,
sculpture and video**
Courtesy the artist and Green
on Red Gallery, Dublin

MARC CAMILLE CHAIMOWICZ

During the 1970s, most of the properties in Approach Road, Bethnal Green, were let to artists by ACME, a housing association offering subsidised studio rents. In what would have been the living rooms were bare, white-washed painting studios lit by neon strip lights. Between 1975 and 1979, however, when number 14 was let to Marc Camille Chaimowicz, an anomalous interior was visible: patterned curtains and wallpaper, comfortable chairs and vases of flowers, elegantly arranged. These furnishings might have been entirely in keeping with the intended function of the terraced house, but erupting in the midst of a succession of workshop spaces, such sensuous domesticity was radically out of place.

Making – in the form of painting, sculpture and design – has always been central to Chaimowicz's practice. But in distinction to the gestural, macho work ethic of abstract and expressionist painting prevalent at that time, he did not separate out the working process and the finished object from the processes and objects of everyday life. Approach Road represented for Chaimowicz both a living space that offered essential solitary retreat, and an ongoing work in its own right; giving the artist the space to formalise ordinary aspects of everyday life at the same time as dissolving the boundaries of 'fine art' to embrace the 'feminised' realms of applied art and interior design. Over time, the house served as the site for performances, for the staging of shots for numerous slides and photographs and for installations incorporating his sculpture, furniture and fabrics. In the intervening thirty years, Chaimowicz's body of work has accumulated gradually and has been consistently re-ordered, and he continues to reject art as a privileged and separate sphere.

Here and There ... 1976–2006 is both a reflection upon, and a compressed representation of, the idea of a 'total environment'. While early works

Born post-war Paris

1968–1970
The Slade School of Fine Art, London

1965–1968
Camberwell School of Art, London

1963–1965
Ealing School of Art, London

Solo Exhibitions

2005
Marc Camille Chaimowicz, Kunstverein für die Rheinlande und Westfalen, Düsseldorf

Galerie Giti Nourbakhsch, Berlin

2003
Cabinet Apartment, Cabinet, London

Group Exhibitions

2006
Egomania. Just When I Think I've Understood, Galleria Civic Modena

2005
Le Voyage Interieur, Espace EDF Electra, Paris

2002
St. Petrischnee, Migros Museum für Gegenwartskunst, Zurich

2000
Live In Your Head, The Whitechapel Art Gallery, London

1998
Out of Actions: Between Performance and the Object 1949–1979, The Museum of Contemporary Art, Los Angeles

Lives and works in London and Burgundy, France

such as *Celebration? Real Life* 1972 experimented with the live presence of the artist who invited visitors to join him for coffee and discussion, Here and There is a kind of stage set without actors, loaded with potentiality and anticipation. Re-worked for Tate Britain, the installation comprises an arrangement of Marcel Breuer's Isokon furniture, a static slide of the artist as a young man examining his reflection in the mirror, a sequence of coloured transparencies of interiors, and another sequence of black and white images of the artist engaged in simple domestic activities. Within the space a vase of flowers is set on a table, and a silver pendulum swings back and forth, while images cast by the projector fall onto a backdrop, which is interrupted by the shadows of the objects themselves. The related performance *Partial Eclipse ...* (first performed in the early 1980s, including once at Tate in 1981) will be re-staged by the artist within the programme of Live Works. Both works collapse two-dimensional representations of 'here' and 'there' to effect the sensation of partial recall: the photographic slides offer glimpses of a life lived, but they are partly obliterated by shadows cast from objects and bodies situated solidly in the present.

Catherine Wood

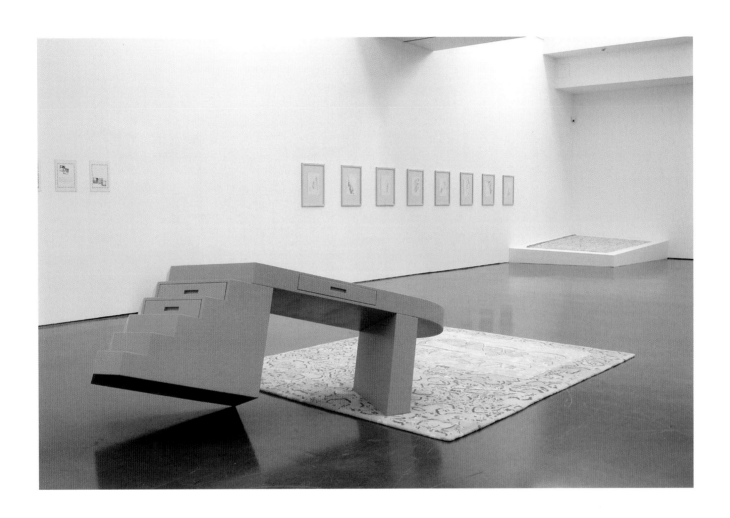

Marc Camille Chaimowicz

Desk ... on Decline 1982–2003
Wood and cellulose
92 x 140 x 220

Carpet 1992
Wool. 277 x 231

Tapestry 2005
Wool. 225 x 172

Installation at Kunstverein
für die Rhienlande und
Westfalen, Düsseldorf, 2005
Courtesy Kunstverein Düsseldorf
and Cabinet, London

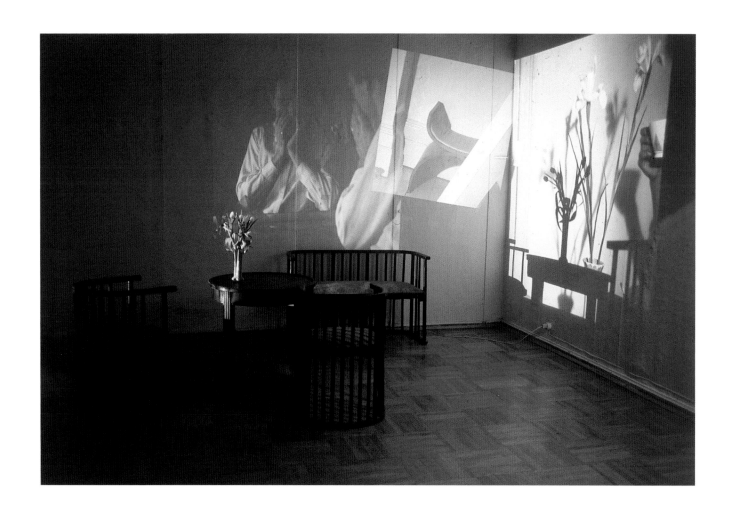

4

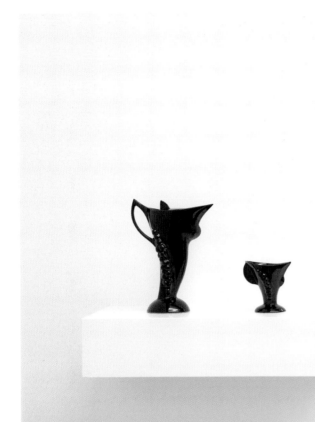

Marc Camille Chaimowicz

Service à café Confluence
1991–1993
Coffee pot, milk jug,
glazed earthenware
Dimensions variable

Partial Eclipse...
Artwork for the artist's book
Café du Reve, chapter 4, 1985
Photographs, texts on paper
Each sheet 32 x 24

Installation at Kunstverein
für die Rhienlande
und Westfalen, Düsseldorf
Courtesy Kunstverein Düsseldorf
and Cabinet, London

LALI CHETWYND

Lali Chetwynd makes oil paintings and stages theatre performances in the unruly spirit of carnival, circus or Marx Brothers comedy. The dialogue between these two strands of her practice rests not simply in the way that both deal with constructions of fantasy, but in the process of their making. Like the finely painted miniature pictures in her series on the absurdist theme of the *Bat Opera*, the props, costumes and scenery for her theatre pieces are painstakingly handmade from a bricolage of discarded materials that she recycles, including fabric, cardboard and gouache paint. An equivalence between the stage and the arena of the canvas is proposed in the work, the oil paintings appearing as imagined set designs for as yet unrealised, or perhaps unrealisable, productions. The narrative structures inhabited by Chetwynd's performances are taken from sources familiar to the collective imagination: early works played out crude versions of films such as *The Wicker Man* 1973 or *Conan the Barbarian* 1982, as well as a makeshift live version of the ghoulish video for Michael Jackson's *Thriller* that erupted in the midst of a club night. Mining the gap between image surface and live presence, Chetwynd presented a selection of flat cut-out, photocopied paper masks in her first solo show at Miller's Terrace (now Herald St) in 2004. Later works have evolved into more complex hybrid conceits, including a three-act play accompanied by John Barry's original score for *Born Free* 1966 at Gasworks and a low-fi remake of the 1924 sci-fi film *Aelita Queen of Mars* at Bloomberg Space. *Debt* at the Institute of Contemporary Arts involved the combination of elements from medieval Mystery plays with Adamite characters from the paintings of Hieronymus Bosch, a booth for personal financial counselling as a tribute to Alvin Hall and a sculptural version of *Hell's Mouth* alongside elements based on Giotto's frescoes, set to a rock, folk and heavy-metal soundtrack.

Born in 1973
in London

2002–2004
Royal College of Art, London

1996–2000
The Slade School of Fine Art, UCL, London

1992–1995
UCL, London

Solo Exhibitions

2005
The Walk to Dover, commissioned by Studio Voltaire, London (performance)

2004
Born Free – The Death of a Conservationist, Gasworks Gallery, London (performance)

Bat Opera, Millers Terrace, London

2003
An Evening with Jabba the Hutt, The International 3, Manchester (performance)

Group Exhibitions

2005
Debt – A Morality Play, Becks Futures, ICA London (performance)

Iron Age Pasta Jewellery Workshop, Do Not Interrupt Your Activities, Royal College of Art, London

2004
Erotics and Beastiality, New Contemporaries, Liverpool Biennale

2003
Richard Dadd and the Dance of Death, Golden Resistance, Tate Britain, London (performance)

Lives and works in London

Chetwynd's work reconsiders what is at stake in the idea of 'performance' as it relates to the history of the genre, especially regarding post-war ideas of 'body art' and communal participation. Instead of presenting her live work as an authentic encounter between audience and performer, she creates scenarios borrowing from street theatre and carnival culture, as well as from the conventions of scripting and staging theatre plays. She invites a wide range of friends, acquaintances and family members to play parts, making and designing their costumes and props to create fantastical moving tableaux. The politics of the work are not simply in the presentation of the artist's own subjectivity, although she usually takes part herself, but in her inclusive and exploratory approach to group dynamics among those who participate as actors and musicians. Her dense and colourful presentations are generous towards the assembled, often mobile, audience, whose physical presence actively constitutes and disrupts the division between performers and audience. In common with the experimental films of Jack Smith, Chetwynd's 'found' narratives serve as an exoticised pretext through which she can explore relational interaction – collaboratively transforming the participants through fictional roles, costumes and masks. Her approach to their involvement registers an attempt to fit her requirements to their own fantasies and desires, under the masquerading cover of a collective suspension of disbelief.

Catherine Wood

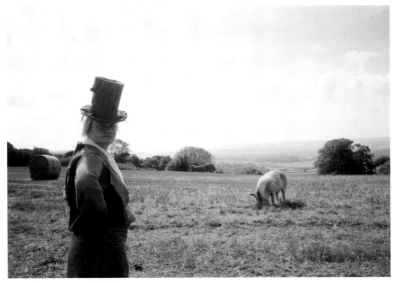

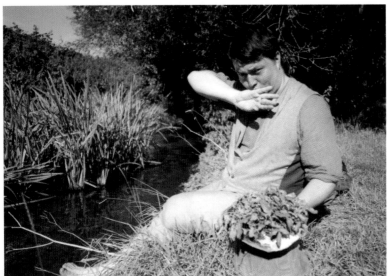

Lali Chetwynd
Walk to Dover 2005
Performance stills
Courtesy Herald St, London

Lali Chetwynd
Born Free Sketches 2004
Pencil on paper
Each 22.8 x 17.5
Courtesy Herald St, London

5

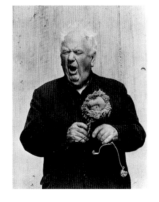

Lali Chetwynd
Bat Opera 2005
Oil on canvas paper
Each 15 x 20
Josef Dalle Nogare Collection, Italy
Courtesy Herald St, London

COSEY FANNI TUTTI

During the late 1970s, Cosey Fanni Tutti made a conscious decision to locate one aspect of her artistic practice within the pornographic industry. Her approach positioned her in direct opposition to the didactic exploration of gender politics favored by her contemporary female artists, and to what she saw as the restrictive dictates of feminism.

As a founder member of the performance-art group COUM Transmissions and Industrial band Throbbing Gristle, the sex-industry offered Cosey a unique experience and opportunity to explore multiple identities. The resulting published magazine features carried myriad self-portraits in which she adopted the personalities required by the story-line, commissioning editor or photographer; all contriving to satiate the reader's libidinous gaze.

Her tactic was to re-contextualise the languages of art performance, rock music and pornography within and outwith their respective operational spheres. This in turn revealed how disparate time frames, place and intention can confer different meanings on a woman's identity. Her self-adopted name, a play on the title of Mozart's opera *Così fan tutte* ('As all women are'), indicated a counter response to female stereotyping and a subtle form of appropriation. Cosey's appropriation also extends to the sex industry itself and importantly the complicity of the viewer, especially the male readership to which her pornographic image was directed.

In 1976, for the exhibition *Prostitution*, mounted by COUM Transmission at London's Institute of Contemporary Arts, Tutti presented extracts from the porn magazines for which she had modelled. The show also featured an array of COUM's performance reliquary, including Tutti's used tampons, soiled clothes and syringes, as well as framed photographs of the group's public actions. The magazine images were intended to be shown as a single body of work on the gallery walls in their original magazine format. However, the threat of censorial action on the part of the authorities prompted the ICA and COUM to relegate the soft-porn images to wooden boxes available to members of the public only on request and one at a time.

Outrage over *Prostitution* was vehemently expressed in the national press, lampooned in satirical cartoons, and denounced in feminist journals including *Spare Rib*. Questions were also raised in the Houses of Parliament. The press reaction was embraced by COUM and newspaper cuttings incorporated on a daily basis within the exhibition display at the ICA, thus providing viewers a contemporaneous chronicle. (There is, within this exhibition, a bound facsimile of the press cuttings.)

Tutti's practice is concerned with re-framing experience. In this exhibition, she presents a selection of published material taken from her pornographic magazine actions alongside factual information and personal annotation. While deliberately entering the sex industry as part of a wider project, she abandoned the theatricality and analytical detachment associated with some modes of performance art. Each modelling action Cosey undertook was a personal test and explored the sex model experience, magazine as mediation and self-image.

That Tutti's practice migrated between different disciplines – for example, the modelling cards appearing as part of Throbbing Gristle's promotional material or sex industry props making their way into performance actions (and vice versa) – demonstrates Cosey's single artistic identity in control of the adopted personalities and self-portraits according to varying pornographic genres.

Born in 1951 in Hull

Selected Solo Exhibitions

2005
In the Vitrines, Van Abbemuseum library, Eindhoven

Selflessness 2, Trace Gallery, Cardiff

2001
Re-VIEWED, Station Gallery, Frankfurt

Selected Group Exhibitions

2005
GO BETWEEN at Bregenzer Kunstverein & the Magazin 4, Bregenz, Austria

2004
The Future has a Silver Lining – Genealogies of Glamour, Migros Museum, Zurich

2003
Independence, South London Gallery

2002
Hotel Sub Rosa, Marc Foxx Gallery, Los Angeles

1999
Village Disco, Cabinet, London

Lives and works in Norfolk

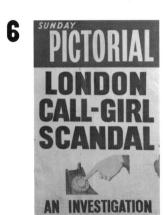

6

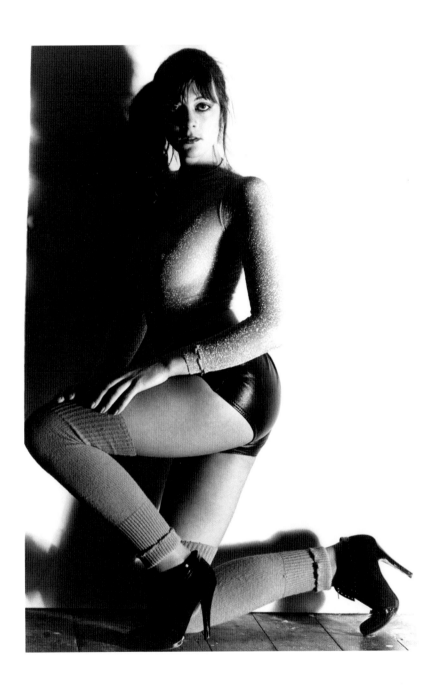

Cosey Fanni Tutti
Photograph by Szabo 1977
Shot used for Cosey's
official Throbbing Gristle
personality card. 30 x 19.8
Courtesy the artist

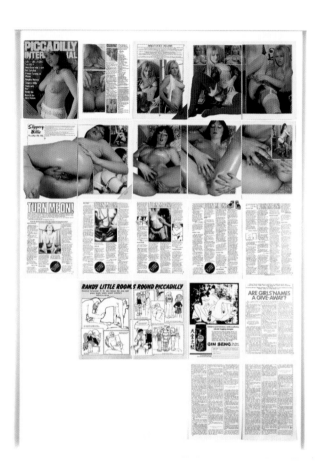

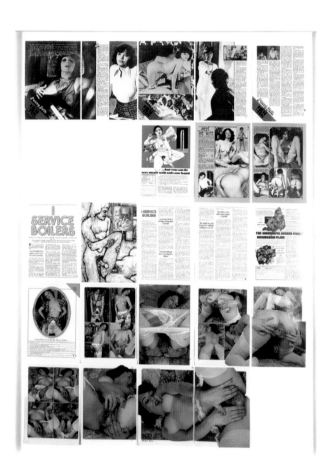

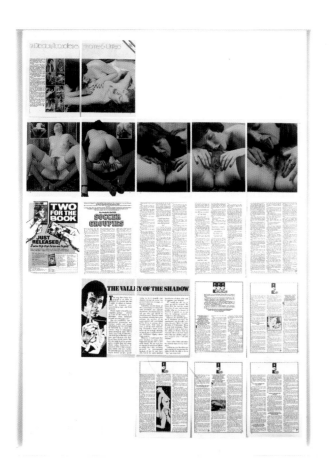

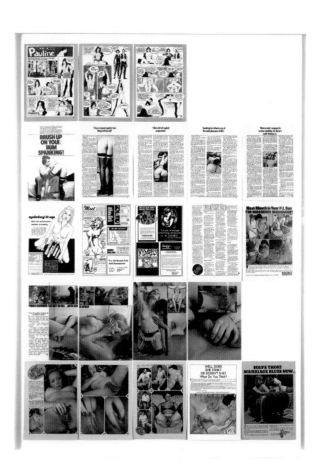

Cosey Fanni Tutti
Piccadilly International Vol 10.
No.10 1976–2005
Framed magazine pages
Four parts. Each part 164 x 120
Courtesy Cabinet, London

ENRICO DAVID

Enrico David's practice embraces a diversity of cultural codes, interacting with their intrinsic language and meaning. From high art to craft techniques to theoretical texts, from functional objects to museum display, his works exude an existential pungency, chafing against the rules that they inhabit to expose an unruly, emotional response to reality. Using as his raw materials such motifs as 1930s marquetry, 1970s bedspreads and pickled onions, David produces an art that is full of unresolved conflicts.

Rather than pursuing stylistic coherence, David's practice is deliberately discontinuous and evasive. Steeped in anachronisms, his works combine unexpected materials and motifs, whose properties and associations interact uneasily. In the 1990s he made large embroideries that subverted both fashion illustrations and modernist design. Models' faces were stitched over, and their perfect legs stretched seamlessly into the chairs on which they sat. *Spring Session Men*, an installation made in 2003, borrowed the language of Art Deco to inveigle the viewer into a sinister and sexually charged board-room. Twelve faux-marquetry men – moustachioed, besuited and with criss-cross limbs – formed an interlocking pattern of brown, black and cream geometries on one of the walls. A table scattered with memos bearing double entendres was overlooked by a phallic, wall-based sculpture, part corporate logo, part Masonic herald, which oozed esoteric symbolism. Through its historical allusion and very particular social codes, but insufficiency of information, the room courted the viewer to imagine a wider context – to deduce, perhaps, a minor history located somewhere in the moral dereliction of the 1930s.

Despite the eclecticism of David's works, they manifest a pervasive awkwardness and embarrassment, a psychological charge that is rooted in the physical. *Crotch Flosser*, a painting made in 2004, deals harshly with bodily rituals. It portrays a fully dressed man, grimacing with concentration as he runs what looks like dental floss between his legs. Referencing Max Ernst's *The Robing of the Bride 1940* through the theatricality of the subject's ablutions, and painted in a sparse, pent-up style, the work takes self-repression to a painful but humorous level. *Douchethatdwarf*, an installation from the same year, featured two figures, accompanied by a dwarf, grandly displaying a shoe whose heel was a papier-maché turd. *Evenly Suspended Attention 1–5*, a series of bedspreads made last year, portray humanity with similar indignity. Wriggling around such Minimalist symbols of perfection as Piet Mondrian's grid compositions and the concentric squares of Josef Albers, are human-animal hybrids, half snake, insect or chicken. Their harassed expressions, scrawny forms and undecided status as men or beasts emphasise the gap between human ambition and actuality.

For the *Triennial*, David will present *Triennial Outlet*, conceived as an interaction between the institution, marketing and the personal. A number of objects, including past and recent works, collaborative projects, found images and works by other artists, are displayed within the confines of the gallery shop. This disruption of the language of retailing, like David's misuse of so many other cultural templates, allows him to test his relationship with the world.

Gair Boase

Born in **1966**
in Ancona, Italy

1991–1994
Central Saint Martins College of Art and Design, London

Selected Solo Exhibitions

2005
Art Now, Tate Britain, London
Galerie Daniel Buchholz, Cologne
Cabinet, London

2004
Douchethatdwarf, Transmission, Glasgow

Selected Group Exhibitions

2005
British Art Show 6, Hayward Gallery Touring

2004
Flesh at War with Enigma, Kunsthalle Basel, Switzerland

2003
Clandestine: Dreams and Conflicts – The Dictatorship of the Viewer, 50th Venice Biennale

2002
The Best Book about Pessimism I Ever Read, Kunstverein Braunschweig, Germany

Lives and works in London

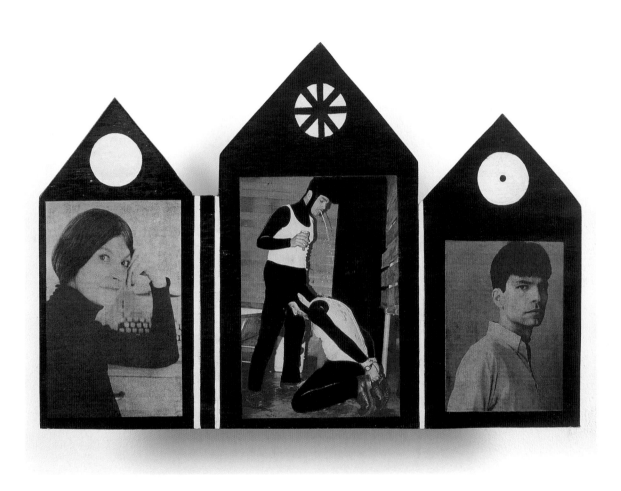

Enrico David
*Choking on a Tearful
Response* 2004
Wood, newspaper cuttings,
paint. 46.5 x 32
Courtesy Cabinet, London

7

PETER DOIG

Peter Doig paints from photographic sources, using a mixture of found images and his own photographs. Snapshots and references from art history, film and popular culture are among his starting-points. Whether photographs of winter sports or a still from a Pasolini film, Doig is interested in images that have a universal point of recognition, that are not too specific but which tap into a collective sense of memory. Before embarking on a painting, he always analyses and distils his source material - often copying, enlarging, editing, re-photographing or collaging it with other pictures. In this way his use of photographs can be understood as a surrogate for preparatory drawings. Doig then filters his disparate sources through his rich and consistent imagination. Ideas develop, dissolve and re-form in the shape of a finished painting.

Throughout his career, Doig has continually returned to the subject of the lone figure in a landscape, or in an internal setting, often structured around tripartite horizontal bands. Such images range from *Girl in a Canoe* 1987, based on a still from the horror film *Friday the 13th*, to *Metropolitain (House of Pictures)* 2004, an image of an artist or collector in a gallery, derived from Daumier's *Amateur d'estampes* 1863-5. Mood and atmosphere are often conveyed through colour, reinforced by Doig's sophisticated and personal language of painting, where the image is built up in layers of paint. Recent works such as *Paragon* 2004 and *Red Boat (Imaginary Boys)* 2004 draw on the decorative impulse within the primitivist strand of modernism: from Gauguin and Matisse to Die Brücke and Munch.

Doig's pictures often have a dreamlike quality, like childhood memories. For example, in *Gashtof zur Muldentalsperre* 2004, set at night-time, two men in carnivalesque theatrical attire stare blankly out at the viewer in front of a backdrop that resembles a stage-set. The word

Born in **1959**
in Edinburgh

1989-1990
Chelsea School of Art, London

1980-1983
Central Saint Martins College of Art and Design, London

1979-1980
Wimbledon School of Art, London

Selected Solo Exhibitions

2005-2006
Peter Doig: Works on Paper, Dallas Museum of Art, Dallas

2004
Metropolitain, Pinakothek der Moderne, Munich

2003-2004
Charley's Space, Bonnefanten Museum, Maastricht, Netherlands

1998
Peter Doig: Blizzard Seventy-Seven, Kunsthalle Kiel, Germany

Selected Group Exhibitions

2004
Carnegie International, Carnegie Museum of Art, Pittsburgh, USA

2003
Pittura / Painting: From Rauschenberg to Murakami, 1964-2003, Dreams and Conflicts - The Dictatorship of the Viewer, 50th Venice Biennale

2002
Cavepainting, Santa Monica Museum of Art, California, USA

Cher peintre - Peintures figuratives depuis l'ultime Picabia, Centre Pompidou, Paris

Lives and works in Trinidad

'Petruschka', the name of a ballet by Stravinsky, is misspelt around the edge of the painting. The work refers to the time when Doig and a friend, both working as dressers at the London Coliseum, themselves slipped into the extras' costumes. Yet even when reinforced by this information, the work retains its elusiveness. It seems strangely familiar and yet displaced. This highlights the fact that in the modern age, our memories have become essentially photographic. Seldom can clear distinctions be made between those memories based on direct experience and those that are mechanically mediated. Our recollections are increasingly supplemented, shaped, structured and recomposed by the internet, photography, film and video, and are open to revision and amendment. In this sense, Doig's images are at once known and yet unidentifiable. Emotions are dredged up and hazy recollections surface through what Carl Freedman has eloquently characterised as the pull of the painting's 'undertow'.

Clarrie Wallis

Peter Doig
Gasthof 2004
Oil on canvas. 275 x 200
Private Collection

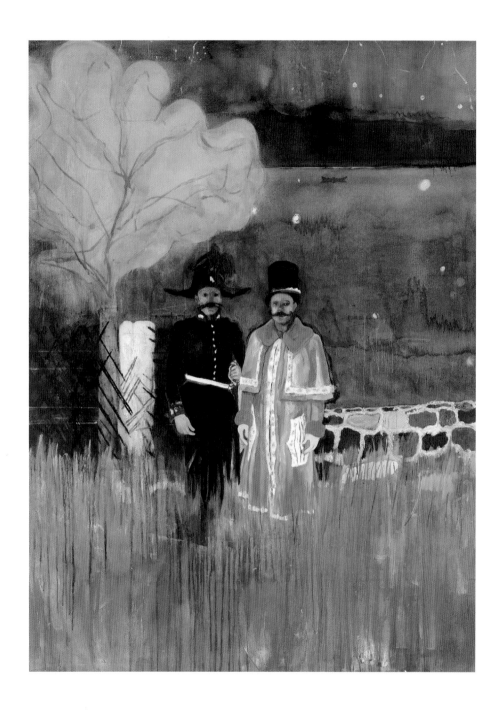

8

KAYE DONACHIE

Kaye Donachie uses found footage of rebellious and revolutionary groups as source material to further her investigations into group dynamics and power structures. She is fascinated by the coercive codes and rituals of cults, communes and other youthful non-conformists. Film and historical biography are an important point of reference. Donachie collates rare footage and cult documentaries that chronicle collectives, from the Manson family and Friedrichshof Commune to Kommune 1 and the sanatorium at Monte Verità. Her interpretation of the material transcends a portrayal of any one specific group of people, however, reflecting instead an interest in redeeming images from the margins of history.

In her small-scale painting *Epiphany* 2002, she focuses on a group of long-haired protagonists lounging languidly around a woodland rock pool. The figures are clad in jeans, democratic wear adopted by American college students, placing the image firmly within the West Coast counter-culture of the 1960s. The mise-en-scène recalls Cézanne's painting *Large Bathers* 1899–1906 of a group of women in a forest glade. On the right-hand side a female figure sits with arm outstretched. Behind her, another figure echoes the frontal nude leaning gracefully against a tree in Cézanne's painting.

Donachie considers that painting is an appropriate medium through which to probe beliefs and all their paradoxes. Her distinctive palette of sickly sodium yellow imbues the paintings with a mysterious glow that resonates with cinematic overtones. Her concern is with representing a mood rather than with expressionism and gesture. The painting's shifting tonal planes reinforce the sense of unease. Figures are often bleached into ghostly abstraction or semi-obscured by shadows, suggestive of a collapse of utopian ideals and optimism.

Born in 1970
in Glasgow

1995–1997
Royal College of Art, London

1995–1996
Hochschule der Künste (H.D.K), Berlin

1989–1992
University of Central England, Birmingham

Selected Solo Exhibitions

2005
Monte Verità, Maureen Paley, London

Peres Projects, Los Angeles

2004
Never Learn Not To Love, Artists Space, New York

2004
Epiphany, Maureen Paley, London

Selected Group Exhibitions

2005
Ideal Worlds, Kunsthalle, Frankfurt

2003
Peripheries Become the Center, Prague Biennale 1, Galleria Nazionale Veletrzni Palac, Prague

Lives and works in London

While Donachie revisits faded dreams and unfulfilled promises, this is combined with a complex, ambivalent attitude to nostalgia. Her interest lies in manipulating and commenting on cultural references or themes that have, over time, become embedded in our collective consciousness. These range from Lynette 'Squeaky' Fromme, to the actor Mark Frechette, the main protagonist of Antonioni's film *Zabriskie Point* 1970, a member of the Lyman cult who carried out a bank raid as desperate political statement against 'everything that is choking this country'. As Donachie explains, 'The references operate like narrative structures.'[1] In this way she uses familiar cultural icons as a shorthand to bridge complex relationships between past and present.

Clarrie Wallis

9

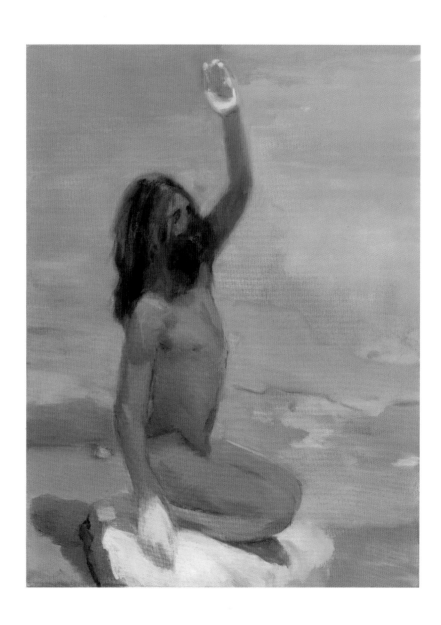

Kaye Donachie
*Your untold dreams I love
to see* 2005
Oil on canvas. 56.5 x 41.9
Courtesy Maureen Paley
and Peres Projects, Los Angeles

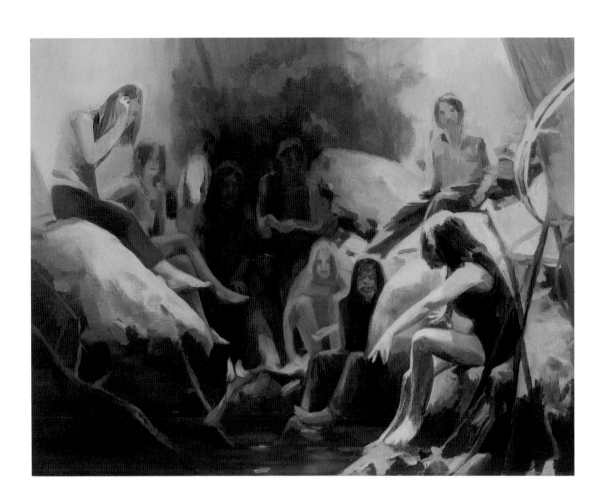

Kaye Donachie
Epiphany 2002
Oil on linen. 36 x 46
Courtesy Maureen Paley

Kaye Donachie
Lilith 2004
Oil on canvas. 62 x 46
Courtesy Maureen Paley

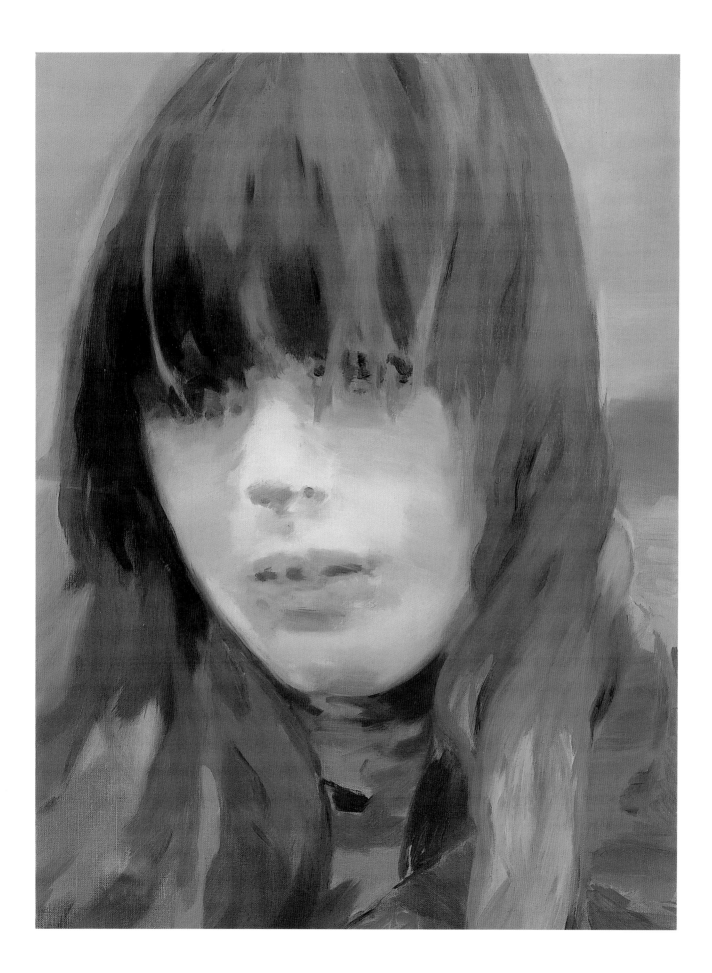

IAN HAMILTON FINLAY

Recently having celebrated his eightieth birthday, Ian Hamilton Finlay is widely fêted as one of the most important British artists of his generation. His practice stems from poetry, which he began writing in the mid-1950s, and is characterised by a pursuit of simplicity and concision. It finds its realisation in graphic work, sculpture, installation, textual materials and his garden, 'Little Sparta', which he considers a *Gesamtkunstwerke* – a total work of art – in which all of the above interact with nature.

Finlay's visual work began as an investigation into concrete poetry, which focused on words as objects in their own right. Such poems brought the visual aspect, the placement of words and letters, to the fore. In the mid-1960s he began making 'found poems', taking words from their original location and assigning them new, invented designations, such as in the poem *Sea-Poppy 2* 1968, which positioned the names of boats in flower-like, concentric circles. Other found poems reduced the form to its most radical level, that of a single word, and dispensed with the need for the page altogether. 'It seemed obvious to me that one could not have a literally one-word poem on the page, since any work must contain *relationship*; equally one could (conceivably) have a one-word poem in a garden, if the surrounding were conceived as *part* of the poem.'[1] Sandblasting poems into glass, chiselling words into stone and wood and placing them at certain points within his garden allowed for the subtle interplay of relationships that Finlay sought.

In exploring the relationships between the meanings and the appearances of words, Finlay teases out both visual and philosophical symmetries and widens the possibilities for metaphor and connotation. His work has also developed to include objects, sculptures and architectures that relate back to history and mythology. For instance, the three columns shown at Tate Britain relate as a group to the first ship of classical myth, Jason's

Born in 1925 in Nassau, Bahamas

Selected Solo Exhibitions

2005
Sentences, Inverleith House, Royal Botanic Garden, Edinburgh

2002
Maritime Works, Tate St. Ives, Cornwall

1999
Variation on Several Themes, Joan Miro Foundation, Barcelona

1995
Works: Pure and Political, Deichtorhallen, Hamburg

1993
Wildwachsende Blumen, Lenbachhaus, Munich

1987
Inter Artes et Naturam, Musée d' Art Moderne

Selected Group Exhibitions

1987
Documenta 8, Kassel

Lives and works in Stonypath, Scotland

Argo, using wordplay to evoke this ancient story. *Blue Waters Bark* 1999 hinges on the spelling of 'bark', the alternative literary spelling 'barque' (meaning boat) being written suggestively around its neighbouring column *Nymph / Ship* 1999. Together the works evoke the story of the Argo, a ship made from hollowed out pines; the title referencing the Mediterranean, the sky and the blue of the pines. A further relationship enriches the works: they are made in collaboration with the stone carver Peter Coates. Frequently incorporating the skills of high quality craftsmen, Finlay evades issues of self-expression, loading his works with a breadth of aesthetic associations.

Finlay eschews modernism's chase of the new in favour of an enquiry into the eternal values of Piety, Beauty and Truth, and returns again and again to the same themes, particularly those of Arcadia and the Sea. He explains: 'In most contemporary art that I see, the artists never seem to love anything ... I know repetition can be very difficult and dangerous, but a lot of my work proceeds frankly from affection and love.'

Gair Boase

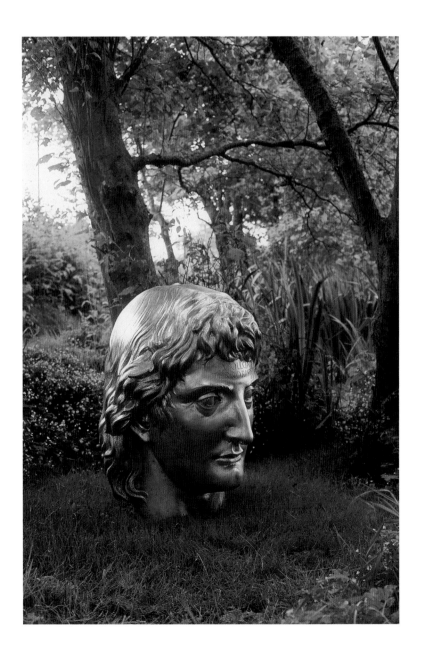

Ian Hamilton Finlay

Women of the Revolution
1993
12 Pots. 148 x 50 x 59
Produced with Keith
Brockwell

The Sound of Running Water
1989
Wall text
Dimensions variable

Installation in *Idylls
and Interventions*
Victoria Miro Gallery, 2003
Courtesy the artist and Victoria
Miro Gallery, London

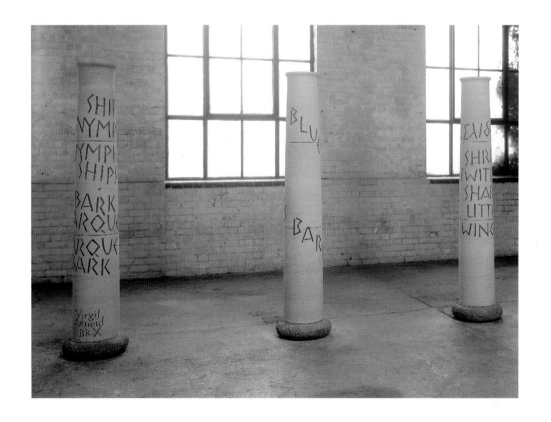

Ian Hamilton Finlay

Nymph / Ship 1999
With Peter Coates
Stone

Blue Waters Bark 1999
With Peter Coates
Stone

Swallow 1999
With Peter Coates
Stone

Each column
200 x 44.5 (diameter)

Installation in *Idylls
and Interventions*,
Victoria Miro Gallery, 2003
Courtesy the artist and Victoria
Miro Gallery, London

LUKE FOWLER

Luke Fowler's work has often involved investigations into various forms of counterculture, foregrounding neglected histories and bringing radical and experimental ideas and ideologies back into discussion. To date he has made three films, each of which has profiled a radical thinker. The first centered on the controversial psychiatrist RD Laing and the Philadelphia Association's 'Kingsley Hall community', a social experiment which sought to redefine conceptions of madness, creating an alternative mental refuge centre that attempted to break down the hierarchy between doctor and patient. The musician Xentos Jones was the subject of his second film. One of the founding members of the underground punk band The Homosexuals, he went on to produce numerous solo projects under different pseudonyms as an anti-careerist strategy to evade musical representation. Fowler's most recent film is English composer Cornelius Cardew's Scratch Orchestra.

Cardew initiated the Scratch Orchestra in 1969 as an avant-garde orchestra that brought together experimental composers with 'musical innocents' to collaborate on seemingly random, fragmented music in performances that could be compared to 'happenings', with pioneering forms of mass improvisation and composition, using new methods of notation including verbal, graphic or collaged musical scores. The orchestra was constructed according to the view that 'anyone can play', bringing together between fity and a hundered musicians at any one time. Central to its constitution was the idea that music had a potential 'use value' and that musicians could form a productive role in society. Cardew's manifesto-like 'Draft Constitution' described the orchestra as a 'truly social body' intended to function in the public sphere. The orchestra's initial anarchic tolerance took the form of a cultural protest aimed to counter the music establishment, orthodoxies of 'taste'

Born in 1978
in Glasgow

1996–2000
Duncan of Jordanstone
College of Art, Dundee

Selected Solo Exhibitions

2003
The Way Out, Cubitt Gallery,
London

2001
*UTO: The Technology
of Tears*, Casco Project
Space, Utrecht, Holland

2000
The Social Engineer,
Transmission Gallery,
Glasgow

Selected Group Shows

2005
Becks Futures, ICA, London

2002
Manifesta 4, Frankfurt

2000
Beyond, Dundee
Contemporary Arts

Lives and works in Glasgow

and the commercialism of the pop industry. This position proved to be unsustainable for the Scratch Orchestra and discontent began to spread, forcing a collective self-criticism. Out of this criticism their past avant-garde music was repudiated to make way for a new politically engaged orchestra, striving to make music to serve the masses.

Fowler takes these fundamental internal contradictions as the focus of his film, using found footage, first-person interviews, archival materials and reinterpretations of the original texts. As in his earlier films, he experiments with the documentary to find a format that reflects the nature of the subject and ultimately reveals his own struggle with the implications of representing this musical, social and political predicament.

Fowler's research into these different characters has become inspiration for other areas of his practice, which includes organising performances, lectures and events, as well as playing in bands and releasing music through his record label Shadazz. Like the Scratch Orchestra, he does not differentiate between the different areas of his practice, but sees them as mutually informing one another, conflating musical, visual and political ideas.

Emily Pethick

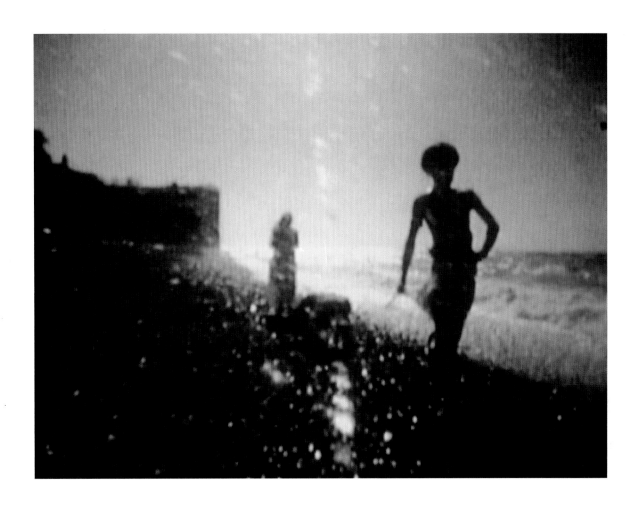

Luke Fowler
The Way Out **2003**
Still from DVD projection
Courtesy the artist and The Modern
Institute, Glasgow

11

Luke Fowler
Shadazz I 2000
Photocopy and CD. 29.8 x 21
Artwork by Toby Webster
Courtesy the artist

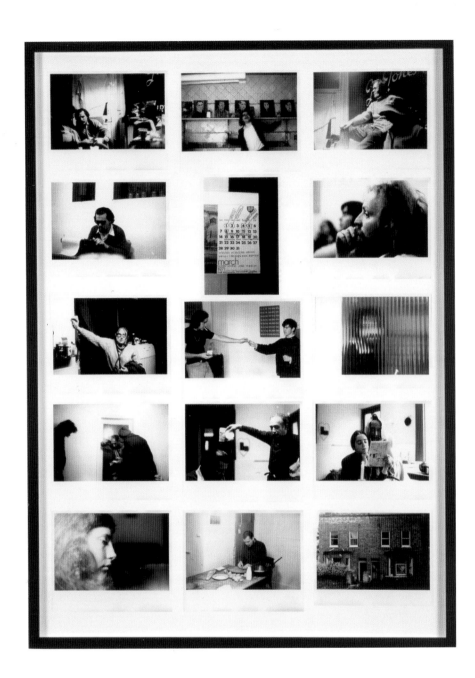

Luke Fowler
Psycho-Analytic Lore
as Truth **2005**
Collage from archives
courtesy of Leon Redler and
Michael Yokum. 122 x 88 x 5
Courtesy the artist and The Modern
Institute, Glasgow

MICHAEL FULLERTON

Michael Fullerton's practice can be characterised as an ongoing investigation into the relationship between information and interpretation. His work, which spans painting, printmaking and sculpture, explores relations between aesthetics and persuasion. Fascinated by the transmission of data, whether it be written, spoken or painted, Fullerton interrogates the reliability of evidence and the nature of truth. These enquiries have ranged from making three-dimensional models of the anatomy of the eye as a means to explore visual perception, to paintings of individuals whose personal agendas are allegorised as aesthetic dilemmas.

In the installation *Suck on Science* 2005, each of the individual elements relates in one way or another to the recording and dissemination of information. The work includes the use of urethane and ferric oxide (the material that stores the signal on magnetic audio tape) as paint, the microphone once employed by the veteran broadcaster, Alistair Cooke, and a full- length portrait of the champion of new music, the recently deceased DJ John Peel. These elements were presented alongside a large roll of unused newsprint and a series of black and white screen prints of the philosopher Friedrich Nietzche's dinning room, pasted directly on to the wall. Here the image was printed repeatedly until the ink ran out – suggestive of the distortion of ideas.

Alongside these questions is a far more fundamental one: that of belief, whether in information that is essentially second hand or in one's own convictions. Fullerton's Gainsborough-style portraits (an artist Fullerton believes particularly embodies his concerns with aesthetics, politics and ethics) are all of people with strong opinions. For example, *A Loyal and Beautiful Aesthete For a World That Didn't Care* 2004 is a painting of Michael Collins, who served a two-year prison sentence for his role in anti-capitalist riots in

Born in **1971**
in Bellshill, Scotland

2000–2002
Glasgow School of Art

Selected Solo Exhibitions
2005
Suck on Science, CCA, Glasgow and Art Now, Tate Britain, London
2003
Are You Hung Up?, Transmission Gallery, Glasgow

Generator Projects, Dundee

Selected Group Exhibitions
2004
Quodlibet, Galerie Daniel Buchholz, Cologne
Wider than the Sky, 117 Commercial Street, London
2003
Bloomberg New Contemporaries, Cornerhouse, Manchester
Prague Biennale
Collective Gallery, Edinburgh
2001
Gwangju Biennial, South Korea
Project Space, Athens
Transmission Gallery, Glasgow

Lives and works in Glasgow

London, while *Stuart Christie: I love my world* 2006 is of a Glaswegian anarchist who tried to assassinate General Franco in 1964. Fullerton's technical fluency in the handling of paint does much to enforce the connection with Gainsborough's evanescent style of painting. As he explains: 'It's interesting to me that while Gainsborough documented and validated a certain political class, his first love was landscape. He loved painting for its own sake.'[1] In adopting an aesthetic system or colour scheme from the eighteenth-century, Fullerton investigates the complex cultural, political and economic context associated with Gainsborough and, in broad terms, the role of the artist. This ambition is not ironic but reflects a genuine curiosity about the physical presence of paintings and a desire to bridge two concerns: to be expressive and exploratory in formal terms and to interrogate the ethical dilemmas inherent in a contemporary artist.

Fullerton's understanding of the responsibility of the artist, as well as the physical act of painting, links with his belief that painting is a form of direct action – that the physical act of painting constitutes a subtle enforcement of political violence onto, and into the ideological battleground which is 'culture'. In a desire to balance the nuances of politics and aesthetics, *Beatrice Lyall* 2006 his recent painting of a survivor of domestic violence, can also be understood as an exploration of the politics of representation – between painter and painted – aesthetics and the creative process. Thus the overriding themes of communication, translation and the filtering of information are tackled in a forceful way making a thoughtful yet provocative intervention into current art.

Clarrie Wallis

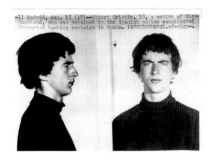

12

Michael Fullerton
Who Cares What You Think
(Stuart Christie) 2005
Oil on linen. 175 x 86
Courtesy Counter Gallery, London

Michael Fullerton
David Milligan (Surveillance
specialist, Glasgow City
Council, Housing Benefit
Anti-Fraud Unit) 2004
Oil on linen. 90 x 70
Courtesy Counter Gallery, London

RYAN GANDER

Ryan Gander's practice employs multiple layers of fact and fiction, as well as lateral modes of thought, in order to draw together associations that make visible the codifications and subtle narratives within everyday life. The work is often experienced as a kind of puzzle that ultimately reflects back on itself.

Gander's *Robbed us with the sight of what we should have known* 2005, has three parts. A monolithic sun-bleached modular cork wall bears the imprint of an absent collection of documents from its previous life as a pin board in Gander's studio. The now invisible documents were used as a basis for the different elements of the work itself, which Gander describes as research towards 'the introduction of a fable into the fabric of reality'.[1] When moved to the gallery, the cork tiles were shuffled into a random formation, thus becoming an empty index to the work and the possible relationships held within it, in the form of a scrambled jigsaw puzzle.

Gander recently invented the word 'mitim', which he has attempted to enter into common language on numerous occasions. 'Mitim' is a palindrome, derived from the conjunction of the words mythical (suggesting a fictional origin) and etymology (suggesting a word that has arrived at its current meaning through a historical path). It thus becomes a term to describe a word that has recently been introduced into language but that has a false history. In *Robbed us with the sight of what we should have known*, the word 'mitim' can be found by solving a crossword puzzle on the back of a stack of newspapers that has been constructed around the word. The fact that the word is not yet commonly known, however, makes this puzzle impossible to solve.

A photograph of a Hackney council estate forms the third component of the work. Added into the foreground of the image is an object that appears to be permanently installed – a seemingly out of place-looking milestone or stumbling block. The block is made from a remixed concrete that is made from the debris of a selection of 'historically significant modernist buildings', all of which have suffered from 'concrete cancer', including Goldfinger's Trellick Tower and Lubetkin's Penguin Pool. With the backdrop of a housing block – most probably a spin-off of one of these great architects' designs – this reconstituted concrete forms both a spatial displacement of, and a reference to modernist ideals and the recycled realities that they gave birth to.

Gander describes *Robbed us with the sight of what we should have known* as seeking to find 'as many possible systems to allow a story to live on without any maintenance from the instigator'.[2] Within the complex layers of assembled objects and traces, and the multiple narratives that circle around them, the work treads the borders of fact and fiction and visibility and invisibility, destabilising notions of certainty and opening up the realms of possibility.

Emily Pethick

Born in 1976
in Chester

2001–2002
Rijksakedemie van beeldende kunsten, Amsterdam

1999–2000
Jan van Eyck Akademie, Maastricht, Netherlands

1996–1999
Interactive Art, Manchester Metropolitan University, Manchester

Selected Solo Exhibitions

2005
Artist Space, New York

Basel Statement with Annet Gelink Galerie, Switzerland

GB Agency, Paris

Somewhere between 1886–2030, STORE, London

Cornerhouse, Manchester

2003
But It Was All Green, STORE, London

Selected Group Exhibitions

2005
T1, Castello di Rivoli, Turin

Becks Futures, ICA, London

In the Colonies, The Fort, Vijfhuizen, Netherlands

2004
Romantic Detachment, PS1, New York

Lives and works in London

Ryan Gander
The Puzzle Collector **2005**
Veneer shelf made from
mahogany, oak, birch
and ash, set into a
white recessed shelf. 3 x 30 x 127
Installation at STORE,
London, 2005
Rosetta Collection, Amsterdam
Courtesy the artist and STORE,
London

13

Ryan Gander
Mitim (studio) **2005**
Digital image
Dimensions variable
Courtesy of the artist and STORE,
London

Ryan Gander
*An Incomplete History
of Ideas
Part 1
Bauhaus Revisited* 2003
**Bauhaus chess-set from
1924 designed by Josef
Hartwig, reproduced in
blacklisted Zebrawood
from the African rainforest**
Cranford Collection, London
Courtesy the artist and STORE, London

LIAM GILLICK

Operating in 'the vast central area that includes bureaucracy, compromise, conciliation and so on', Liam Gillick has established himself as one of Britain's most versatile artists. His work spans sculpture, graphic design, architecture and fiction, always maintaining a clearly recognisable signature style, but one based entirely on a pre-existing vocabulary. Asserting that 'there is no "The idea", there are maybe 20,000 ideas flickering between the illusion of the present and the illusion of the past', Gillick engages with the semiotics of the built world, utilising pre-formed materials and ideas. In doing so, his works expose and explore a tension between our society's ideologies and its operating systems.

Sculptures made by the artist in the 1990s adapted the legacies of Minimalism – the use of industrial materials, cubic constructions and instructional texts – and consistently advertised an intention to facilitate social change. Yet such works deliberately undercut their utopian aspirations by mimicking the parlance of corporate and governmental culture, where conference centres, platforms and think tanks (all words used in Gillick's titles) perpetually promise untold solutions. Using contemporary rhetoric and materials they quote the post-industrial society back at itself.

Texts are a crucial component throughout Gillick's practice. Usually presented in Helvetica font, these can take the form of instructions, graphic and sculptural design, or create a number of fictions. Increasingly, Gillick has privileged the appearance of the text over its content, overlapping words so that what is written cannot be read. Recent exhibitions such as *Presentism* and *Factories in the Snow* have related to an ongoing text by the artist provisionally entitled *Construcción de Uno*. This follows a group of ex-factory workers who return to their former place of work, which has been shut down, and attempt to reconfigure modes

Born in **1964**
in Aylesbury,
Buckinghamshire

1984–1987
Goldsmiths College,
University of London

Selected Solo Exhibitions
2006
Liam Gillick: Edgar Schmitz,
ICA, London
2005
A short text on the possibility of creating an economy of equivalence,
Palais de Tokyo, Paris
2003
Literally, Museum of Modern Art, New York

Communes, Bars and Greenrooms, The Powerplant Contemporary Art Gallery, Toronto
2002
The Wood Way, Whitechapel Gallery, London

Selected Group Exhibitions
2004
Singular Forms, Guggenheim Museum, New York
2003
Utopia Station: Dreams and Conflicts – The Dictatorship of the Viewer, 50th Venice Biennale

What If, Moderna Museet, Stockholm
2000
Intelligence: New British Art, Tate Britain, London

Lives and works in London and New York

of production by improvising with the redundant factory signage. They hope to establish an 'economy of equivalence', an impossible efficiency in which the effort and ideas expended produce an equal return. Through a series of hanging texts that spin off from this unfinished fiction, Gillick plays with the power exerted by logos in our culture and their promise of never diminishing returns.

If Gillick's sculptures experiment with the distance that ideas must travel from conception to realisation, his methods of working attest to an idealism driven by pragmatism. Frequently collaborating with artists and non-artists alike, his projects are enriched by multiple personalities. *Briannnnnn & Ferryyyyyy* (2004), an animation made with the artist Philippe Parreno, developed from an interdisciplinary seminar that examined the relationship between law and creativity, The film was complicated by the involvement of a film company and the use of music and font that were originally designed for other purposes. Furthermore, the artists also brought together a semi-autonomous group of curators and critics for the project and incorporated their advice into the credits. Similarly, Gillick's designs for public buildings such as the new Home Office building work within existing parameters to effect viable improvements. His work is an acknowledgement that 'while there's clearly a problem, there's no reason to stop thinking about how things might be better.' Through the seductively simple seating plans for a conference room, for instance, the cleaning of a museum's glass doors, or the gem-like beauty of 'spangled' Plexiglas ceilings, Gillick effects a functional utopianism.

Gair Boase

Liam Gillick
Telling Histories 2005
Installation at
Kunstverein München, 2005
Courtesy Esther Schipper Gallery,
Berlin

14

Liam Gillick
*The hopes and dreams
of the workers as they
wandered home from
the bar 2005*
*Installation at Palais
de Tokyo, Paris, 2005*
Courtesy Air de Paris, Paris

Liam Gillick
Övningskörning
(Driving Practice) 2004
**Blackpowder-coated
water-cut aluminum
8 elements, each 240 x 30
Installation at Milwaukee
Art Museum, 2004–2005**
Courtesy the artist

DOUGLAS GORDON

Douglas Gordon's diverse practice, which encompasses film, photography, sound installations and text-based works, explores memory, identity, perception and meaning. Using predominately found material he investigates themes such as temptation and fear, good and evil, life and death. Truths, fictions, the familiar and the strange are manifested on screen, tattooed upon flesh and spelled out on gallery walls in order to highlight the shifting subjectivity of our perception of the world.

The mirror – reflecting, reversing and doubling the image – is an important formal and conceptual element in Gordon's practice. Present as both a structural and metaphorical device, the artist's use of the mirror or mirrored image is suggestive not only of the condition of doubling which is so essential to his work but also of the co-existence of duplicate realities. In Gordon's video installations, the looming physical presence of the actual film screen, propped on the floor, dropped on its side or multiplied, transforms viewing into an involved, intimate and at times overwhelming experience. For example, *Through a Looking Glass* 1999 recasts 71 seconds of a famous scene from Martin Scorsese's film Taxi Driver (1976). In Gordon's piece Travis Bickle is pitted against himself through a double projection on opposite walls. A verbal altercation takes place between the two mirror images, and the question 'You talking to me?' is bandied about the room.

Elsewhere Gordon has developed the theme of the ego's search for recognition and anxiety about the transience of life. While he has created many self-referential works throughout his career that fuse autobiography and fiction, in the recent exhibition *The Vanity of Allegory* (2005), Gordon appropriates the self-portrait as an art-historical trope. This is combined with vanitas symbols as a means to reflect on the ephemeral nature of life. At the same time Gordon questions whether self-

representation is itself an act of vanity and ploy to remain immortal. For example, the sculpture *Proposition for a Posthumous Portrait* 2004, references the artist's persona, but also borrows from art history. The work consists of a human skull placed within a corner mounted mirrored cube. The skull with its carved star, recalls *Haircut for de Zayas* 1921, Man Ray's photograph of Duchamp, where the artist lathered his scalp and shaved off his hair in the form of a star. Robert Mapplethorpe's haunting photograph *Self Portrait* 1988 with skull-headed staff in hand is also deliberately referenced as is Robert Morris's *Mirrored Cubes* 1965 and *Displacements* 1969 Robert Smithson's use of mirrors in landscape. Smithson, like Gordon has an interest in the mirror's potential to fracture as well as to reveal. Works such as *Proposition for a Posthumous Portrait* seemingly reflect upon Smithson's statement: 'A mirror looking for its reflection but never quite finding it.' Gordon proposes the self as an enigma; that we are often strangers to ourselves.

Siobhan McCracken

Born in **1966**
in Glasgow

1984–1988
Glasgow School of Art

1988–1990
The Slade School of Fine Art, London

Selected Solo Exhibitions

2000
Douglas Gordon, Tate Liverpool

2001
Douglas Gordon, Museum of Contemporary Art, Los Angeles

2002
Douglas Gordon: What Have I Done, Hayward Gallery, London

2003
Letters, Telephone Calls, Postcards, Miscellaneous, 1991–2003, Van Abbemuseum, Eindhoven

Selected Group Exhibitions

1999
48th Venice Biennale, Italian Pavilion

2000
The British Art Show 5, Hayward Gallery Touring

2002
Point of View. A Contemporary Anthology of the Moving Image, The New Museum of Contemporary Art, New York

2005
Cut / Film as Found Object in Contemporary Video, Museum of Contemporary Art, Miami

Lives and works in Glasgow and New York

Douglas Gordon
*Proposition for
a Posthumous Portrait*
2004
Skull and mirror
Dimensions variable
Courtesy Sean and Mary Kelly,
New York

15

MARK LECKEY

Mark Leckey mines the surface of the perceptible world for pre-existing images and sounds, which for him represent moments of identification or desire. Stitching them together, harlequin-like, Leckey makes what might be described as four-dimensional collages, in the media of video, sculpture or live performance. Though they are all, in a sense, self portraits, these individual works only ever capture fragments of the artist's actual presence – perhaps his voice, his image or his living space.

Installed together for the *Tate Triennial*, Leckey's video works *Made in 'Eaven* 2004 and *Drunken Bakers* 2005 create a surreal, asymmetric diptych on the theme of what it means to make art. Drawing the viewer in to their hallucinatory double chamber is the fast-fire 'trailer' *Gorgeousness and Gorgeosity* (2005) which opens with a shot of the artist's studio flat, familiar from previous works. Here, though, the room is seen in reverse, bulging and distorted. As the camera pans back it becomes apparent that the image is a reflection captured in the surface of a curved object: the mirrored shell of Jeff Koons's silver bunny, from his *Celebration* series, and an abbreviated extract from *Made in 'Eaven*. The soundtrack is sampled from Stanley Kubrick's *A Clockwork Orange*: 'Oh Bliss. Bliss and Heaven. Oh yes, it was Gorgeousness and Gorgeoisity made flesh. It was like a bird of rarest spun heaven metal, or like silvery wine flowing in a spaceship. Gravity all nonsense now...'. Crashing down from the high pomp of its Regency-inspired opening titles, the trailer ends with an abject image of the *Viz* magazine characters, the *Drunken Bakers* written by Barney Farmer and drawn by Lee Healey. One of the Bakers (spoken by Leckey himself) confides in a whisper, 'I thought I saw something...'.

Like Leckey's earlier work, *Parade* (2004) the looped five minute film generates an accelerated cycle of vision and delusion that speaks of the combination of practicality and aspiration at stake

Born in 1964
in Birkenhead

Selected Solo Exhibitions

2004
Septic Tank, Gavin Brown's enterprise, New York
Parade, Cabinet Gallery, London

2003
Migros Museum, Zurich

2000
London, My Part in its Downfall, Galerie Daniel Buchholz, Cologne

Selected Group Exhibitions

2004
Faces in the Crowd, Castello di Rivoli, Turin; Whitechapel Gallery, London

2003
Fast Forward / Media Art Sammlung Goetz, ZKM, Karlsruhe, Germany

2002
Shoot the Singer: Music on Video, Institute of Contemporary Art, Philadelphia

2000
Protest & Survive, The Whitechapel Gallery, London

Lives and works London

in making art: the bunny embodying a level of physical, almost immaterial, perfection that, for the Bakers, is perpetually out of reach. Leckey also uses the shorter piece to insert disjunctive flashes of image material cut from magazines, as though they are readymade surrogates for a thought process in his pop-culture-clogged imagination. In these films Leckey's own self-image is literally absent. But in both works he takes pre-existing cultural artifacts and tests his subjectivity as an artist against them, effecting a two-way transformation in which he inhabits them, and they inhabit him.

In *Made in 'Eaven* Leckey shows the pristine surface of Koons's sculpture to be liquefied by its own mirrored perfection. It reflects the surrounding environment so lucidly that it sucks in the artist's living space (used by Leckey in previous works as a stand-in for his own presence) to the extent that the room's fireplace and symmetrical bays metamorphose into substitute features for the bunny's blank face. The studio space, in turn, is warped by the looking-glass lens of the shiny surface and appears engorged to bursting point, as though inflated by its encounter with the famous sculpture. In contrast to the sophisticated computer technology used to make this piece the world of the *Drunken Bakers* comprises straight shots of the found cartoon rendered in rudimentary pen and ink. Rotten and fluid with cake mixture and vomit, this world is kept in its uncooked state by the continuous pouring of wine. Recordings of Leckey's voice resonate with real depth and pathos behind the flat images, equating his own artistic practice with the Sisyphean endeavour of the bakers who begin each episode with grand plans for new productions which perpetually fail.

Catherine Wood

Mark Leckey
Gorgeousness & Gorgeosity
2005
Design for screen print
by Lee Healey
Courtesy Cabinet, London

Mark Leckey
Made In 'Eaven **2004**
Still from 16mm film
Tate

16

Mark Leckey
Untitled 2003
Mixed media.
218.4 x 157.5 x 25.4
Courtesy the artist, Cabinet, London
and The Zabludowicz Art Trust

LINDER

Linder began her career in the early days of the punk scene in Manchester, where she contributed to, as well as documented, the movement. Her practice comprises collage, photography and performance, weaving a concern with the presentation of self through an attack on stereotypical images of femininity put to the service of consumerism. Inflected by the underground punk context in which she performed as lead singer in the group Ludus from the late 1970s to the early 1980s, Linder's work is nevertheless underwritten by a wider exploration of the relations between the individual and collective, or society and the outsider. To this end she has inhabited the characters of figures such as Ann Lee, the founder of the Shaker movement in Manchester in the eighteenth century, or Clint Eastwood, playing the fictional lone cowboy, combining cross-historical identification with the disruption of gender norms.

In the late 1970s Linder made a series of photographs of men attending drag nights in a Salford pub. The subversive quality of these documentary pictures is heightened by the gap between the obvious maleness of Linder's subjects and their attempts to pass at femininity. Her work in general oscillates between the presentation and obliteration of self-image, obscuring with collage or make-up or transforming with disguises. In images of herself from 1981 for example, made in collaboration with photographer Birrer, she used clingfilm, bandages and paint to alter her own appearance. At an early Ludus performance she ripped off her wrap-over skirt in a kind of anti-homage to Buck's Fizz, who had just won the Eurovision song contest, to reveal a large black dildo. On her top were sewn pieces of meat discarded from the butchers.

The process of making is important to the ethos of Linder's practice, a counter to branded, ready-made objects. Her work is a form of Pop art for the punk era, after the collages of Richard

Born in 1954
in Liverpool

1974–1977
Manchester Polytechnic

Selected Solo Exhibitions
2004
The Lives of Women Dreaming, British Council, Prague
2000
The Return of Linderland, Cornerhouse, Manchester

The Working Class Goes To Paradise, Manchester (performance)
1997
What Did You Do in the Punk War, Mummy?, Cleveland Gallery, London

Selected Group Exhibitions
2003
Glamour, British Council, Prague

Plunder, Dundee Contemporary Arts
2001
DEAD, The Roundhouse, London
1998
Destroy, Royal Festival Hall, London

Lives and works
in Lancashire

Hamilton or Eduardo Paolozzi, via Martha Rosler. It operates at the margins of culture, stitching together discarded elements with exquisite care to see what they might reveal. Her graphic montage for the Buzzcocks' 'Orgasm Addict' album cover 1977 depicted a nude glamour model with a household iron for a head and nipples replaced by smiling mouths. Early untitled collages used found pornographic images in combination with banal advertisements for domestic and electrical goods, effecting surreal conflations of the consumption of the female body and of products for sale. One, for example, shows a room installed with 'G-Plan' furniture overlaid with a cut-out image of a couple engaged in mutual masturbation, their heads replaced by television sets showing horse-racing from Saturday afternoon sports TV. Some of these collages appeared in the journal that Linder co-edited with Jon Savage, *The Secret Public*, published early in 1978. In the pornographic magazine collage, *Pretty Girl no. 1*, Linder inserted images of clocks, an iron, a hoover, a washing machine to cover the faces of the naked women, as substitutions or object-masks. In 2000, Linder made a body of work, *The Return of Linderland*, which included a performance in north Manchester entitled *The Working Class Go to Paradise*. She invited three Manchester bands to play continuously and simultaneously for four hours, while she and four other women performed movements taken from drawings of Shaker rituals. The participants played the roles of both performers and audience, and the piece became akin to a private ritual of lamentation. Building on her exploration of the relationship between the loner or outsider figure and collective ritual, Linder will re-enact this performance as a part of Live Works in the *Tate Triennial*.

Catherine Wood

Linder
She She 1981
Photograph by Birrer
30.4 x 24
Courtesy the artist

Linder
The Working Class Goes
to Paradise 2001
Silkscreen from photograph
by Ruth Bayer. 60 x 84
Courtesy the artist

Linder
June 1970 2004
Silkscreen with gold leaf
102 x 72
Courtesy the artist

LUCY McKENZIE

Lucy McKenzie weaves a loosely connected web of references, adopting and reworking stylised modes of representation, such as those framed by the political ideologies of the former Communist states, in order to set up pictorial tensions that explore individuality versus collectivism and vernacular idioms against global culture. A continual interest has been in the embodiment of the creative individual, in particular the female artist, explored through paintings, short stories, performance and film.

Recently, McKenzie's work exploits the language of cartoon illustration, in particular the genre of erotic cartoon art. *Untitled* 2005 depicts a young woman eating in a generic, bourgeois restaurant, incongruously sitting beneath a cartoon rendition of a woman masturbating. The framed scene is taken from the comic book *Click!* by Italian erotic cartoon artist Milo Manara, in which an evil scientist has implanted a chip in a woman's brain so that every time he turns a switch she is uncontrollably aroused. The speech bubble reads 'Hurry Jeanne, get me a salesman', translated into old regional Flemish (the work was made when McKenzie was living in Belgium). Seemingly oblivious to the farcical activity above her head, the diner's gaze is deliberately unconfrontational, inviting identification with the viewer. The scenario is based on an actual encounter in which McKenzie was invited to dine at a private art foundation with its own restaurant displaying works that included Jeff Koons' *Made in Heaven* photographs of sexually explicit poses performed by his wife, the porn star Cicciolina. This experience confirmed for McKenzie how the separation between a space to eat or socialise and the rarefied space for contentious or difficult contemporary art is now blurred. Galleries and museums increasingly seek to host private entertainment to supplement revenue, while luxury hotels and restaurants confirm their status through strategic association with contemporary art and artists.

Born in **1977**
in Glasgow

1995–1999
Duncan of Jordanstone
College of Art and Design,
University of Dundee

Selected Solo Exhibitions
2005
SMERSH, Metro Pictures,
New York
2004
Bi-Curious, Cabinet, London

Deathwatch,
Van Abbemuseum, Eindhoven
2003
Nova Popularna, Foundation
Galerie Foksal, Warsaw
(with Paulina Olowska)

Selected Group Exhibitions
2003
*Dreams and Conflicts – The
Dictatorship of the Viewer*,
50th Venice Biennale
2002
Painting on the Move,
Kunsthalle Basel,
Switzerland

*The Best Book About
Pessimism I Ever Read*,
Kunstverein Braunschweig,
Germany

Lives and works in Glasgow

The painting also obliquely refers to the fascination of late nineteenth-century artists such as Edgar Degas or Henri Toulouse-Lautrec with prostitutes and barmaids, whom they saw as personifying the liberating forces of social change and Modernism. Their depictions of these women confirmed the view of the time that unaccompanied females in public spaces, particularly at night, were automatically 'available'. McKenzie set out to re-evaluate how women were depicted in this genre in her collaborative project *Nova Popularna* 2003, a temporary salon set up and run for a month in Warsaw with Polish artist Paulina Olowska. They stated, 'We wanted to make these familiar women more than just sexual objects symbolising social and artistic progress; we wanted to give them a life away from the male gaze, make an environment for them and also become them.'[1] Creating an alternative to the traditional exhibition, they made work for the walls of the bar as well as organising live music, djs and slide nights, and commissioned friends to supply home-made vodka and tailored costumes.

McKenzie maintains a hyper-awareness of the context in which art, including her own, is being made and presented. Her strategic use of source material and borrowed imagery is devoid of irony. Instead she follows a unique and eclectic path through the visual codes and styles made relevant by her chosen environment, reworking them in order to reassess and challenge established vocabularies of representation.

Katharine Stout

Lucy McKenzie
Untitled 2005
Oil on canvas. 244 x 183.5
Courtesy the artist and Metro
Pictures, New York

Lucy McKenzie
Deathwatch 2004
Detail of installation
at Van Abbemuseum,
Eindhoven, 2004
Acrylic on brick wallpaper,
exterior wall painting,
projected film
Dimensions variable
Courtesy the artist and Van
Abbemuseum, Eindhoven

18

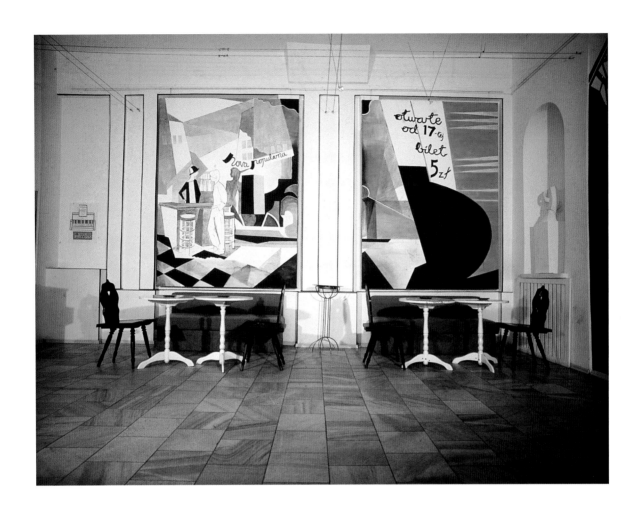

**Lucy McKenzie
and Paulina Olowska**
Nova Popularna **2003
Detail of installation
Galerie Foksal, Warsaw,
2003**
Private Collection
Courtesy Cabinet, London

DARIA MARTIN

Daria Martin's films depict the staging of relationships between performers in choreographies mediated by objects, patterns or formal rules. The communities of people who participate in her intricately constructed worlds often represent, but do not solicit, participatory group activity. As viewers, we are invited to be a part of the work only via imaginative projection. Synthesising dance, music, painting and sculpture, Martin's films propose an alternative place for art: pure aesthetics are grafted on to lived situations, whether entertainment, sport or dramatic narrative. Distinct from commercial media, however, her frank use of low-tech materials to make her costumes and props invites haptic identification with the fantasy space created by the films, allowing them to breathe rather than appearing slick and unobtainable.

Martin borrows from a range of art-historical sources, especially from early twentieth-century *Gesamtkunstwerke* such as Oskar Schlemmer's abstract ballets, Varvara Stepanova or Alexander Rodchenko's Constructivist theatre design and Sonia Delauney's coloured and patterned clothing. But out of step with the logic of modernism, Martin's work is essentially romantic, staging and dramatising the split between the artist's imagination and the world at large. Devised initially as textual scripts, the films are generated via a collaborative process in which Martin works with actors, choreographers and musicians, who bring their own inflection to her principal vision. She casts particular people for their qualities of vulnerability or readability, for how they might exceed her own idea, as much as how they fit into it. Like the male figure looking out over the sublime Romantic landscape in the paintings of Caspar David Friedrich, a central female figure is often the focus, serving as a kind of stand-in for the artist's own subjectivity, and as a threshold marking the boundary of this other world.

Born in **1973**
in San Francisco

2000
University of California

1995
Phi Beta Kappa,
Yale University

Selected Solo Shows

2005
Five Fights, Kunstverein, Hamburg

Daria Martin, Kunsthalle Zurich

Soft Materials,
The Showroom, London

2003
Daria Martin: Art Now Lightbox, Tate Britain, London

2001
Birds, Andrea Rosen Gallery, New York

Selected Group Shows

2005
British Art Show 6,
Hayward Gallery Touring

2004
In the Palace at 4am, Alison Jacques Gallery, London

2003
The Moderns, Museo Castello di Rivoli, Turin

Lives and works in London

Recalling the intimacy of Joseph Cornell's boxes filled with personal objects, Martin's expanded tableaux vivants present equivalences for the dream or fantasy space of the mind as it processes and recycles the material it consumes. Images from history and the present are equally available as references and resources, woven together. Martin seduces the viewer and at the same time reveals the mechanics of seduction: enticing us with sensuous colours, shapes, textures and yet letting us see their makeshift, provisional construction. Her directorial vision digs into the immaterial surface of film's projected shadow-world to add more weight, rubbing against and agitating its flatness. The setting for *Wintergarden* 2005 is the De La Warr Pavilion at Bexhill-on-Sea in East Sussex. Martin infuses the clean lines of its modernist architecture with emotional weight, her actors' movements interpolating the gap between the rough, glittering bleakness of the English coastal landscape and the serenity of this utopian, white 'people's palace' for culture and sport. *Loneliness and the Modern Pentathlon* 2004, meanwhile, charges the abstracted and antiquated ritual of sport with cross-currents of sexual and emotional drive.

Formal aesthetics are tested against the flesh of the world in Martin's work, projecting dynamic trajectories of futuristic aspiration against undercurrents that pull back to the oldest foundations of myth and narrative.

Catherine Wood

19

Daria Martin
Wintergarden 2005
**Stills from 16mm film
projection**
Commissioned by Film and
Video Umbrella in association
with De La Warr Pavilion.
Courtesy the artist and Maureen
Paley

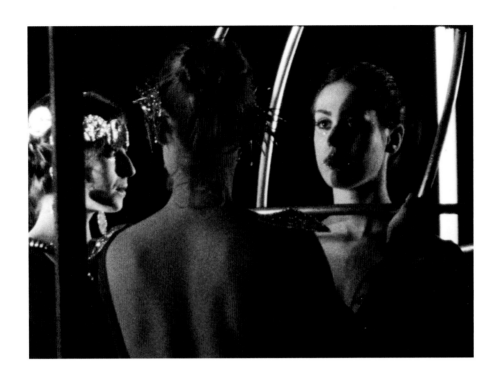

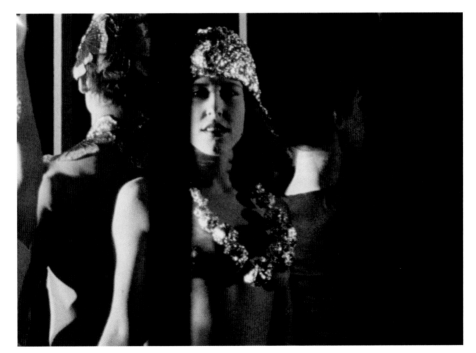

Daria Martin
In the Palace, 2000
Stills from 16 mm
film projection
Courtesy the artist and Maureen
Paley

SIMON MARTIN

Narrated by an anonymous Canadian, the film *Wednesday Afternoon* 2005 is a twelve-minute meditation on the experience of museums: the sense of vanishing time into which they conduct us, the value we accord to things, and the limitations of looking when attempting to unlock the secrets of objects amassed over centuries. filmed in the British Museum and the Victoria & Albert Museum, the work progresses through a sequence of long-held shots of interiors and artefacts – so still they could almost be photographs – which steadily darken as the day grows old. The narrator explains: 'What I want to do is capture the magic of wandering around looking at people and things. I want to do this without disrupting what is there or altering anything that might happen, suspending conclusions and resolutions, keeping things open, somehow remaining critical.' He arrives at no answers, but 'the pace, smell and sound' of the museums that he seeks to capture vibrate in the film's narration and juxtaposition of images.

Caught within the modest gaze of Martin's film is a heft of cultural bounty. It focuses upon the Elgin marbles, Egyptian mummies, vast silver buckets, Elizabethan sarcophagi and African fetish figures – offering the viewer many treasures to look at but never to touch. Surrounded by so much 'stuff pressing into the moment', the narrator confesses that he finds it 'hard to actually care about any of it'. A self-appointed 'man of the crowd', the narrator is a twenty-first-century flâneur, strolling in the increasingly late afternoon of history. At times his ruminations are disingenuously self-reflexive. He remembers Chris Marker's film *Sans Soleil* 1983, whose own narrator describes Tokyo as a vast orchestral score where rhythms are formed through clusters of faces caught in passing. Like the narrator in *Sans Soleil*, who relates the observations he reads in letters written by a correspondent from around the world, Martin's museum-goer experiences cultures second-hand. Both films dwell on faces in the hope of relaying distant civilisations.

Wednesday Afternoon arose out of Martin's dissatisfaction with bringing more objects into a world already sated with things. In the past, he made paintings and sculptures using found objects and images, but he became frustrated by their inability to shrug off their corporeal density. Often these had a lengthy making process apparently at odds with their subjects, as though Martin were trying to slow down the production of things. For *Strawberry Poison Dart Frog* 1998–9, for instance, he spent a year learning how to paint in a photorealist style so as to depict the blur of an instant image. While still manifested as a thing, *Wednesday Afternoon* represents a shift from making objects to contemplating them. Compressing centuries of achievement into the experience of a single afternoon and eliding that afternoon into just twelve minutes, the exchange of time for the quizzicality of artefacts finds succinct expression; its ephemeral form offers a rejoinder to the cultural weight of ages.

Gair Boase

Born in **1965**
in Cheshire

1985–1989
The Slade School of Fine Art,
UCL, London

Selected Solo Exhibitions
2005
Counter Gallery, London
White Columns, New York

Selected Group Exhibitions
2005
Critical Celebration,
Galerie Karin Guenther
Nina Borgmann Hamburg
*In the Poem About Love you
Don't Write the Word Love*,
CCA Glasgow
Argos film festival, Belgium

Lives and works in London

Simon Martin
***Wednesday Afternoon* 2005**
Still from DVD projection
Courtesy the artist and Counter
Gallery, London

20

ALAN MICHAEL

Alan Michael maintains a detached relationship with the diverse sources for his compelling yet perplexing paintings. A comment made in an early interview indicates his stance: 'Someone once said to me "Why would you put something you're interested in into your work?" and I kind of agree with that.'[1] His borrowed themes move freely, and seemingly without connection, between paintings by early twentieth-century art-historical figures such as Stanley Spencer, a recent film by Lynne Ramsey – *Morvern Callar* 2002, set in Scotland – and fashion products and imagery. An early work, *Misty in Roots* 2001, presents an imaginary magazine cover complete with a contents list of obscure international cultural and political figures. Foliage lifted straight out of an early Lucian Freud work frames the blank space at the centre of the canvas. Collectively these eclectic references point to a private, almost impermeable vocabulary, raising questions as to whether they should be read as critique, glorification or indifference. This cloaking of meaning makes traditional strategies of appropriation redundant, leaving the viewer slightly stranded, yet intrigued to find out more. The subject of the work is not necessarily what is being depicted, but the structure of the aesthetic exchange between audience and artist.

A recent series focuses on just one subject: an advertising image of a traditional English brogue that is repeated again and again, both within the same picture and over a series of canvases. This shoe can be read as an icon of Britishness, hand-crafted and revered by well-dressed Italian men or City bankers. The shoes are covetable objects, carefully painted to emphasise the quality of the shiny black leather and the expensive hard-wearing soles. The same image is repeated and enlarged from one corner of the canvas to the other or from top to bottom, and as the scale increases, so the motif becomes more abstract. Any meaning

Born in **1967**
in Glasgow

1996–1998
Glasgow School of Art

1992–1996
Duncan of Jordanstone
College of Art and Design,
University of Dundee

Selected Solo Exhibitions

2005
Modern Art, London

2003
Burlesque Schematic, HOTEL,
London

2002
Entwistle, London

Transmission Gallery,
Glasgow

Selected Group Exhibitions

2004
Year Zero, Northern Gallery
of Contemporary Art,
Sunderland

Haute Street, Galerie Diana
Stigter, Amsterdam

2003
*This has reached the
limit conditions of its own
rhetoric*, Modern Institute,
Glasgow

2002
Half a World Away,
Halls Walls CCA, Buffalo,
New York

Lives and works in Glasgow

attached to the choice of subject matter diminishes, as the theme becomes little more than a vehicle for an investigation into composition and the pleasure of painting. As Tom Morton has written: 'his real concern is the moment when his source material fades into a new fiction'.[2]

Michael's practice can be better understood in relation to another artist, whose place at the centre of contemporary art activity has scarcely been acknowledged until now. Elaine Sturtevant was precociously repeating the work of her contemporaries, such as Warhol or Lichtenstein, in the early 1960s, almost simultaneously with their own appropriation of imagery from the world of mass media, and she has continued ever since to create 'faithful reproductions' of seminal artworks, seemingly before they become icons. Michael's approach aligns itself with Sturtevant's ambition to 'expand and develop our current notions of aesthetics, probe originality, and investigate the relation of origins to originality and open spaces for new thinking'.[3] His own use of quotation is unapologetically complicated, part homage, part apathy. Yet the resulting paintings are far from indifferent: Michael's prosaic style is both precise and highly evocative. Just as we cannot presume fully to understand the inner thoughts of another, so his beautiful paintings remain elusive yet enduring.

Katharine Stout

Alan Michael
Untitled 2005
Oil on canvas. 111.5 x 81
Courtesy Stuart Shave | Modern Art,
London

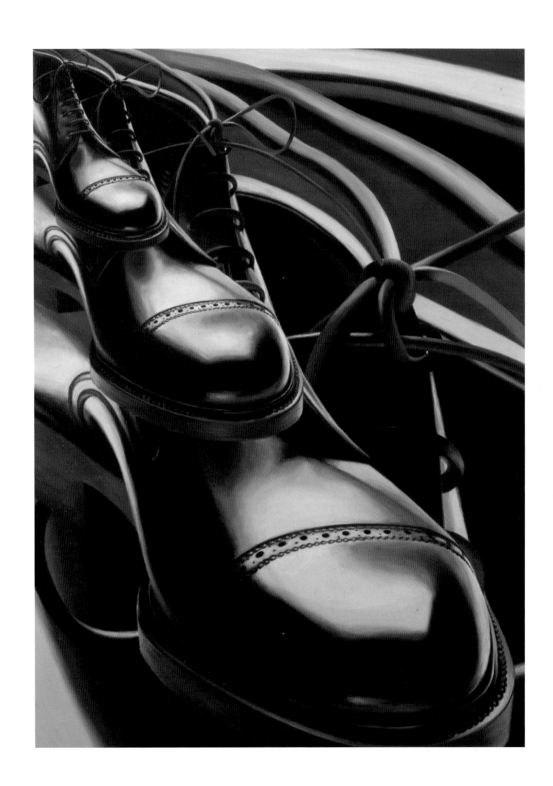

Alan Michael
Positiva 2005
Oil paint on canvas. 103 x 62
Courtesy Sorcha Dallas, Glasgow

Alan Michael
Wargasm 2001
**Silkscreen, acrylic and
pencil on paper. 100 x 65**
Courtesy Stuart Shave | Modern Art,
London

JONATHAN MONK

Jonathan Monk playfully adheres to the principles established in Sol LeWitt's *Sentences on Conceptual Art*, published in 1969, especially No. 14 on the list: The words of one artist to another may induce an idea chain, if they share the same concept. 1969 is the year of Monk's birth and this collision of personal anecdote and high-art vocabulary seems to lie at the heart of his practice. Monk has continually appropriated from LeWitt's work, most specifically in his film *Sol LeWitt: 100 Cubes Cantz/Slow slow quick quick slow/front to back back to front/on its side* 2000, which animates every page of LeWitt's book, *100 Cubes*, presenting it as a continuous 16mm loop.

Combining homage with humour, Monk employs the intellectual strategies and cool aesthetic of Conceptual art of the 1960s and 1970s, yet makes his personal life and its ephemera the subject of his art. For example, he asked family members to interpret his holiday photographs (LeWitt No. 24: Perception is subjective); conceived, through a series of text pieces, a number of future rendezvous that may or may not take place (LeWitt No. 10: Ideas can be works of art; they are in a chain of development that may eventually find some form. All ideas need not be made physical.); and presented fifty photographs, found in a Berlin flea market, in which the first photo contains an image of one person, the second two people and so on, building up to fifty people in the last photograph (LeWitt No. 28: Once the idea of the piece is established in the artist's mind and the final form is decided, the process is carried out blindly.).

In *Twelve Angry Women* 2005, Monk presents a group of found drawings, all made by the same unknown artist during the 1920s or 30s, upon which he has pinned a different coloured drawing pin to the ear of the woman depicted in order to attatch the paper to the wall. The piece is titled after the 1957 film *Twelve Angry Men* in which Henry Fonda

Born in **1969**
in Leicester

1988–1991
Glasgow School of Art

1987–1988
Leicester Polytechnic

Selected Solo Exhibitions
2005
Continuous Project Altered Daily, ICA, London
2004
Sculptures, Neons and Drawings, Galleri Nicolai Wallner, Copenhagen
2003
Time and or Space, The Swiss Institute, New York

Projected Works, Lisson Gallery, London
2002
Roundabout, Art Gallery of Ontario, Toronto

Selected Group Exhibitions
2005
Slide Show, The Baltimore Museum of Art, USA
2004
Play List, Palais de Tokyo, Paris
2003
Adorno, Frankfurter Kunstverein, Frankfurt

Lives and works in Berlin and Leicester

plays a conscientious juror wrestling with his role in the fate of a man accused of murder. The work recalls the notorious *L.H.O.O.Q.* 1919 in which Marcel Duchamp drew a moustache and a thin goatee on a cheap reproduction of the *Mona Lisa*, thus defacing the revered image and claiming it as his own. Yet the idea of borrowing a work from another artist, and in the act of homage partially destroying it, also refers directly to the Willem De Kooning drawing erased by Robert Rauschenberg in 1953. Additionally, these endearing sketches of young women are reminiscent of the work of Francis Picabia, an artist who constantly shifted styles and artistic allegiances, deliberately going against the avant-garde innovations of his peers. This layered act of appropriation is typical of the way in which Monk irreverently, but respectfully, references artists from the last century. In doing so he questions notions of authenticity, disrupting the expectation of truth and originality in art and pushing at the boundaries of how and when an object – or an idea – becomes a unique work of art.

Katharine Stout

Jonathan Monk
Twelve Angry Women 2005
**Vintage drawings with
coloured drawing pins
28 x 21**
Courtesy Galleri Nicolai Wallner,
Copenhagen

Jonathan Monk
Remembering (In Situ) 2005
Three 16mm Films
Installation at Yvon
Lambert, Paris, 2005
Courtesy the artist and Yvon Lambert,
Paris

Jonathan Monk
Sol LeWitt: 100 Cubes Cantz/
Slow slow quick quick slow/
front to back back to front/
on its side 2000
Still from 16 mm
film projection.
Dimensions variable
Courtesy the artist and Yvon Lambert,
Paris

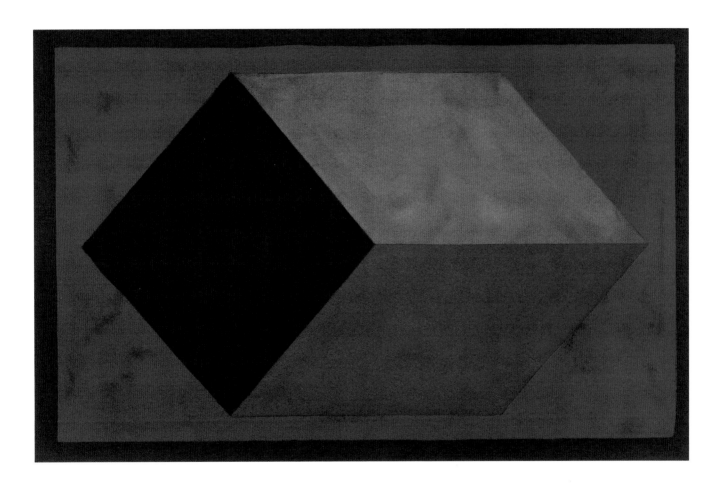

SCOTT MYLES

Scott Myles' practice can be understood as an ongoing act of intellectual and formal enquiry. He employs and moves freely between forms of sculpture, photography, drawing, silkscreen printing and performance-based projects. In 2001 he inverted the prevailing rules of work by paying someone to take cigarette breaks over the course of a day, transforming economic principles. For a year-long project (1999–2000), Myles himself carried out an intervention across Britain's dominant newsagent chains situated in railway stations, systematically 'borrowing' magazines and newspapers from shops and kiosks, as if they were one vast public lending library. He placed a flyer he had printed into each journal before it was returned within the shop chain, often in another part of the country.

Myles also questions the nature of cultural and commercial exchange in works that dialogue with that of two prominent artists who encourage participation on the part of the public: Felix Gonzalez-Torres and Rirkrit Tiravanija. Posters that were originally left by the late Gonzalez-Torres for visitors to take away were personalised by Myles with hand written texts such as 'Learn the Language' or 'Pointing in One Direction'. They are attached to the wall in thin Perspex cases and use the floor for support, making more literal this problematic gesture. These works reveal Myles' interest in modes of display, alluding to museological artifacts encased for exhibition.

Recently Myles has produced a group of sculptures that approximate freestanding screens or large revolving doors. A recurring theme is the way in which hybrid objects gain their meaning through direct engagement with the audience. *Analysis* 2005 combines formal concerns with the act of appropriation, personalising two adopted objects, in this case bus shelters, presented one on top of the other, painted subjectively to approximate light and shadow.

Born in 1975 in Dundee

1993–1997
Duncan of Jordanstone College of Art and Design, University of Dundee

Selected Solo Exhibitions
2005
Kunsthalle, Zurich

The Breeder, Athens

2004
HUO I Want to Know Everything!, The Modern Institute, Glasgow

2003
Jack Hanley Gallery, San Francisco

Galleria Sonia Rosso, Turin

Selected Group Exhibitions
2005
The Last Generation, Apex Art, New York

Theorema, Collection Lambert, Avignon, France

2004
Genesis Sculpture, Domaine Pommery, Reims, France

2003
Context, Form, Troy, Secession, Vienna

Lives and works in Glasgow

Myles' two-part silkscreen work, *The End of Summer* 2001, describes his encounter with Tiravanija's work *Untitled (no fire no ashes)* 2001, while on holiday in Berlin. At the commercial gallery Neugerriemschneider, Tiravanija had blocked up the doorway between the gallery and office with stones, at the same time removing the entrance door to allow twenty-four-hour access to the gallery for the duration of the exhibition. One of the stones is inscribed *Ne Travaillez Jamais* (Never Work), a statement originally declared and publicly disseminated on the streets by the Situationist artist Guy Debord during the violent protests of May 1968 in Paris. For the *Triennial* Myles has approached the artist and is re-presenting Tiravanija's walled-up doorway in Tate Britain, where it exists simultaneously in its own right and as part of Myles' installation. Myles' screenprint depicts a silhouetted figure standing next to the sealed doorway. In an accompanying commentary, he describes visiting the gallery on the last day of his holiday and observing the inevitable transformation of the gallery back to its usual state. His text concludes: 'It felt like the end of summer and time to get back to work.' By describing the episode as a summer diversion, Myles questions the notion of 'work' on many levels. He accepts the invitation for social exchange on which Tiravanija's practice is premised, offering his own highly subjective account of the experience. In doing so, he makes this active involvement the central concern of his work, aligning his position with that of the audience, blurring the separation between artist and viewer.

Katharine Stout

Scott Myles
The End of Summer 2001
Two silkscreen prints
102 x 72 and 50 x 83
Courtesy the artist and
The Modern Institute, Glasgow

23

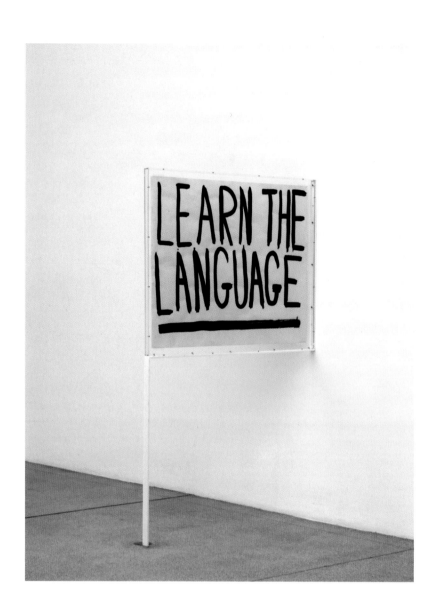

Scott Myles
Learn the Language 2003
Ink on reverse of Felix
Gonzalez-Torres poster
Perspex, steel. 116 x 79 x 4.6
Courtesy the artist and The Modern
Institute, Glasgow

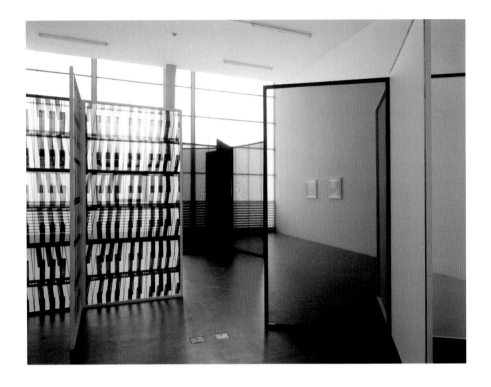

Scott Myles

We are building 2005
Aluminum, georgette, serifix
245 x 233 x 233

Fiction 2005
Aluminum, chiffon, serifix
248 x 267 x 133

More Mountains 2005
Aluminium, voile, chiffon,
georgette, serifix

Installation view, *Scott Myles*,
Kunsthalle, Zurich, 2005
Courtesy the artist, The Modern
Institute, Glasgow, and Kunsthalle,
Zurich

Scott Myles

David Standing 4th May 2004
David Sitting 4th May 2004
2004
Unique silkscreens on paper
silver/black & black
Each 72 x 102

Analysis 2005
Acrylic paint, aluminium,
plexiglass. 465 x 370 x 124

The Contents of a Mini Bar
2004–2005
Acrylic paint, glass,
plastic, motor, plinth
120 x 47.3 x 47.3

Installation view, *Scott Myles*,
Kunsthalle, Zurich, 2005
Courtesy the artist, The Modern
Institute, Glasgow, and Kunsthalle
Zurich

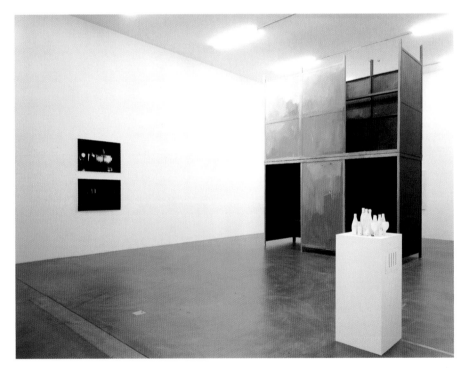

CHRISTOPHER ORR

Within Christopher Orr's small, murky canvases, improbable meetings take place. Dowdily dressed figures carrying handbags confront elemental landscapes as though lost on their way back from the shops; a giant bird communes with a bulky old-fashioned radio; paramilitaries emerge out of russet landscapes that resemble those in eighteenth-century paintings. Placed within mist-drenched, spectacular landscapes, the people inhabiting his paintings seem entirely dislocated in their settings; isolated figures ill-equipped to deal with, and strangely unmoved by, the world around them. Steeped in anachronisms, these miniature paintings jolt old memories. Their figures and landscapes are familiar through other pictures, resonating with what Baudrillard has characterised as 'the discrete charm of second-order simulacra'.[1]

All of Orr's paintings possess a tight style and small size whose consistency makes the world they describe more believable, as though it continues to exist when his back is turned. His colours are the muted ochres, browns and olives of traditional oil painting, and his scenic backdrops are often spectacular Romantic landscapes reminiscent of Caspar David Friedrich and J.M.W. Turner. Recent images of interiors, meanwhile, recall Edward Hopper's lonely domestic spaces.

Orr's use of appropriation comes into its own, however, in the odd assortment of figures who nonchalantly stalk his lands. Sporting the bygone fashions of the 1950s and 1960s, they are scavenged from a collective archive of images – the Kodachrome photographs of old *National Geographics*, Lady Bird 'Easy Reading' Books, junk-shop finds, wildlife handbooks and newspaper images. Intently occupied (often in observing what the viewer cannot see), Orr's people are locked in a solipsistic engagement with the world, oblivious or indifferent to one another. Always maintaining the original size of the figures he borrows, Orr

Born in 1967
in Helensburgh, Scotland

2001–2003
Royal College of Art, London

1996–2000
Duncan of Jordanstone College of Art and Design, University of Dundee

Selected Solo Exhibitions

2005
Sister Gallery, Los Angeles
Before and After Science, Arndt & Partner, Berlin

2004
Of Both Worlds, IBID Projects, London

2003
Future Natural, Cohan Leslie and Browne, New York
In Between Days, IBID Projects, London

Selected Group Exhibitions

2005
Fabriques du Sublime, Centre d'art Contemporain, Noisy-le-Sec, France
(...) The Duck Was Still Alive, Centre d'art Contemporain, Meymac, France
Ideal Worlds: Romanticism in Contemporary Art, Schirn Kunsthalle, Frankfurt

2003
I Want, I Want, Northern Gallery for Contemporary Art, Sunderland

Lives and works in London

makes the banal unsettling and endows his scenes with magic realism: people are often dwarfed by each other and by preternatural animals and plants.

In *Untitled (Dog & Pond)* 2003, a golden labrador emerges from water, its head enormous and God-like compared with the two boys who watch it. *Wherever You Go* 2003 features a giant buttercup hanging in the sky in place of the sun, while a thrush and bluetit loom far bigger than the people who walk in their midst. Such discordant scales diffuse and subvert the pictures' art-historical references, evoking the warped perspectives and magical growths encountered in children's stories such as Tom Thumb and Jack and the Beanstalk, associations further encouraged by the Ladybird-book iconography. But boxed into a few square inches and thrust into the white cube of the gallery, Orr's thumb-sized protagonists make do with stranger, more discontinuous narratives than fairy tales. Their sublime surroundings, similarly confined, are understood only through second-hand mediation.

Orr's works reveal how quickly we relegate memories of the past to the backs of our minds. Through painting, also a potentially defunct form in this digital age, he creates netherworlds that come alive through memory.

Gair Boase

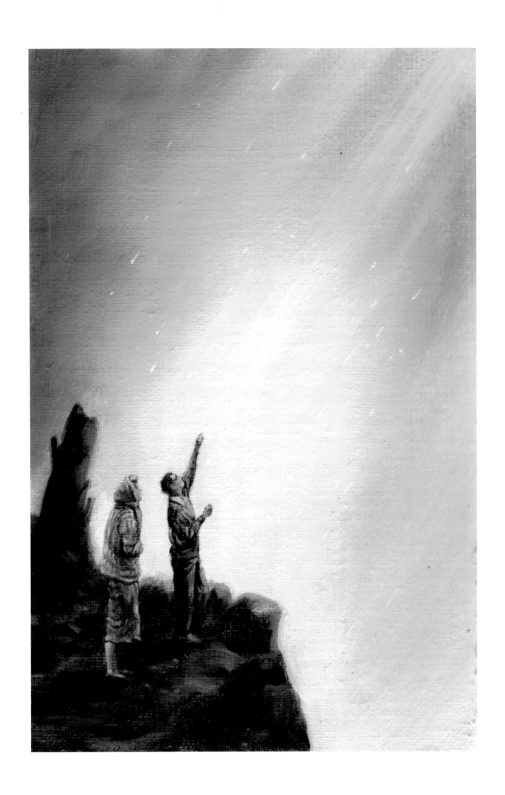

Christopher Orr
*All We Need Is The Air
That We Breathe* **2004**
Oil on canvas. 17 x 11.6
Collection of Magnus Edensvard,
London
Courtesy the artist and IBID
PROJECTS, London / Vilnius

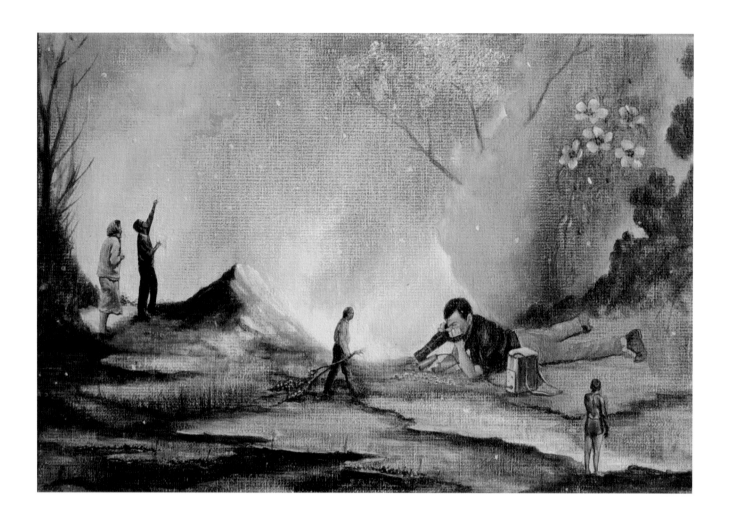

Christopher Orr
Nothing Will Be As It Was 2004
Oil on linen. 21 x 30.5
Private Collection, Switzerland
Courtesy the artist and IBID
PROJECTS, London / Vilnius

Christopher Orr
Hits of Sunshine **2005**
Oil on linen. 16.5 x 19
Courtesy the artist and IBID
PROJECTS, London / Vilnius

THE OTOLITH GROUP

The Otolith Group was founded in 2002 by the artist Anjalika Sagar and the cultural theorist Kodwo Eshun, who collaborated with the artist Richard Couzins to make *Otolith* 2003. This film essay probes the potency of archival images, exploring the poeticisation of mediated memory, and is profoundly influenced by Chris Marker's *Sans Soleil* 1983 and Black Audio Film Collective films such as *Handsworth Songs* 1986. Taking its name from 'otoliths' – the minute particles found in the inner ear that enable us to balance and navigate our way across space – the film aims to inform and orientate our perceptions of the world, weaving personal and public histories together to mourn the passing of utopian aspirations.

'Earth is out of bounds for us now; it remains a planet accessible only through media', the viewer is told at the beginning of *Otolith*, positing a post-nuclear future in which humankind is confined to outer space. Through prolonged space travel, the film tells us, man's otoliths cease to function, leaving people unable to walk the earth. Instead they comb images, 'sifting aging history from the tense present in order to identify the critical points of the twentieth century'.

The film's narrator is Dr Usha Adebaran Sagar, a fictional descendant of Anjalika Sagar, living in space in the year 2103. From this perspective, the narrator looks back at the lives of several generations of women in the Sagar family, linking her own experiences with those of Anjalika's real-life grandmother from the 1960s, such as her encounter with the first woman to enter space, the Russian cosmonaut Valentina Tereshkova, and with Anjalika's contemporary observations on the War on Terror. 'For us', the narrator declares, 'there is no memory without image and no image without memory. Image is the matter of memory.' Her attempts to understand her history and the earth she can never inherit bring together existing images of very different

qualities and registers: 35mm footage of mushroom-cloud explosions of atomic bombs that have indelibly seared the collective consciousness; digital video news footage of London's peace marchers in the run-up to the Iraq war; and private memories captured on Standard 8 film from 1970s London and Haridwar. The artists also shot Sagar floating in micro-gravity at Star City, Russia, where cosmonauts still train. Her physical and temporal dislocation is echoed by the contrasting film stocks, subtly tinting the world different shades as they refract and redefine the past.

Bringing together numerous fractured histories, including those often neglected by the West, such as India and Pakistan's embrace of nuclear armament, *Otolith* projects a 'past-potential future'[1] allowing for a different perspective on the present.

Gair Boase

Anjalika Sagar
Born in **1968**
in London

1993–1996
The School of Oriental and African Studies, London

Kodwo Eshun
Born in **1967**
in London

1986–1989
University College, Oxford

Richard Couzins
Born in **1965**
in London

2001–2003
Birkbeck College, London

1984–1988
Duncan of Jordanstone College of Art and Design, University of Dundee

Selected Group Exhibitions

2005
Homeworks III, A Forum on Cultural Practice, Beirut

VIDEO BRASIL, State of the Art, Sao Paolo, Brazil

Prologue, New Europe New Feminism, Cornerhouse, Manchester

MIR – Dreams of Space, Stills Gallery, Edinburgh

2004
City of Women, Past Transition Welcome to the Future, 10th International Festival of Contemporary Art, Lubljana, Slovenia

Our House is a House that Moves, Skuc Gallery, Ljubljana, Slovenia

Luggage – Dai / Nai, Nanjing Art Institute, Nanjing, China

FLY UTOPIA, Transmediale International Media Arts Festival Berlin

Live and work in London

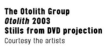

The Otolith Group
Otolith 2003
Stills from DVD projection
Courtesy the artists

25

DJORDJE OZBOLT

Through the prolific production of small-scale paintings, Djordje Ozbolt's dark and romantic vision of the world emerges. Stylistically and conceptually, these condensed, eclectic images cover a wide terrain of sources and references drawn without hierarchy from religious iconography to popular culture and from art history to children's folk tales. Often, a theme emerges as a consequence of the act of painting rather than as the starting point, the process triggering the memory of a cult film watched many years ago, as in *The Pusherman* 2005, loosely based on Peter Fonda's drug-selling character in *Easy Rider* 1969, or a horrific act of terror described on the radio, as in *Suicide* 2004. Yet connections between the works become apparent and particular interests are revealed. These are drawn from aspects of life that have touched or fascinated Ozbolt, such as the turbulent events of his past, his observations during his frequent travels, and his recent art studies; influences that often merge and mutate. For example, *Untitled* 2005 started with an Indian miniature figurative work seen during Ozbolt's regular visits to the subcontinent, and yet once the brush took the lead the character transformed into a Japanese male figure, or hermaphrodite, incongruously placed in a classical European setting. Another painting, *Le Duc* 2005, takes its source from a nineteenth-century book of symbols. The empty coat of arms and the French title refer obliquely to the Revolution and the defeat of aristocracy. The idea for *Fountain* 2004 was based on the Hindu goddess Kali, who is typically represented as a deranged or wrathful naked woman and in some renditions is shown feeding off the blood of her own severed head. Despite the ferocity of her story and image, she is revered as a loving mother to her devotees. Ozbolt turns this fearsome deity into a man, feeding on his own severed head, but also giving nourishment to a young skater boy and his dog. Popular

Born in 1967
in Belgrade, Yugoslavia

2003–2006
Royal Academy of Arts, London

1996–2000
The Slade School of Fine Art, UCL, London

Selected Solo Exhibitions

2006
Herald St, London

2005
IBID Projects, Vilnius, Lithuania

Selected Group Exhibitions

2005
London in Zurich, Hauser & Wirth, Zurich

Other People's Projects, White Columns, New York

Lives and works in London

culture and ancient myth are united to create a disturbing yet intriguing image.

The works presented in this exhibition represent a fraction of Ozbolt's output. His Dadaist spirit is revealed in the deliberate decision not to adhere to one style or technique, instead privileging the fluid outpourings of his imagination. Ozbolt describes his loose, almost casual, way of working as 'restless', explaining that it gives him the freedom to work across different idioms and techniques quickly and without restraint. Conversely, the humble size of his canvases allows him to tackle the most difficult and contentious subjects – suicide bombers, genocide and so on, alongside witty and anecdotal motifs. Fragments of ideas, thoughts and narratives accumulate to build a picture of the world as seen through Ozbolt's eyes. It is a vision that is constantly shifting as his circumstances and experiences alter and grow.

Katharine Stout

Djordje Ozbolt
Ol' Blue Eyes 2004
Acrylic on canvas. 29 x 22
Courtesy Herald St, London

Djordje Ozbolt
Death of a Soldier 2005
Acrylic on canvas. 40 x 50
Courtesy IBID PROJECTS,
London / Vilnius

Djordje Ozbolt
Untitled 2005
Acrylic on canvas. 32 x 32
Courtesy Herald St, London

OLIVER PAYNE and NICK RELPH

Orchestrating a large number of elements – eclectic images, narration, music, subtitles and even Morse code – the films of Oliver Payne and Nick Relph are full to the brim. Their marriage of unlikely elements that jar with one another create a brash, funny, touching and telling whole.

At the core of the duo's work is a profound sympathy for youth. *Driftwood* 1999, their first film together, is a poetic yet excoriating paean to London that commands the viewer to 'navigate your city by an alternative means'. Shots such as an endless line of cars conveyed by train, a rubbish bin bearing an 'I Love You' missive and sunbathers lounging on sculptures all live out this détournement advice. Nothing in the film is being used in the way that it was intended to be and the heroes here are skateboarders and graffiti artists, who adopt the city's surfaces to their own ends. *Mixtape* 2002, the duo's fourth film, is constructed around an edited version of an already cut-up track – Terry Riley's remake of the Motown classic, *You're No Good*. The film abounds with incongruous juxtapositions: ravers and line-dancers mingle under strobe lights, the bejewelled tortoise of J.K. Huysmann's *A Rebours* is transposed from fin-de-siècle Paris to the grimy grey of a London chippie, and the look of the film is intended to be 'like a cross between an insurance ad and *Schindler's List*'.[1] Full of dancing and entirely composed of new footage, the film is a celebration. It exuberantly tramples on cultural clichés, mixes them up and makes them the artists' own.

Recently, the artists' relationship with what appears in their films has grown more complicated. Relph has stated that 'at one point ... we would get inspired and make work through looking at the world around us. I think that when we look at things around us now we tend to see things we can't use, things we can't refer to or use as inspiration.'[2] Instead, references glut their work and deny

any unmediated response to things in themselves. *Comma, Pregnant Pause* 2005, splices together Jar Jar Binks, Samuel Beckett, Pokemon characters, a duck-billed platypus and more to create an intertextual endgame that attests to a media-saturated world in which everything is related and nothing may be experienced firsthand. *Sonic the Warhol* 2005 is similarly bleak. It follows two boys visiting London Zoo, but defaces their heads, as well as those of the animals, with heavily pixellated images taken from mobile phones and computer games, which move in contrast to the natural grace of the subjects. The artists' crude, but often beautiful, juxtapositions suggest that there is no longer any such thing as nature, and that culture frames and inhibits our understanding of the world much like the cages in which the animals are housed.

Gair Boase

Oliver Payne
Born in **1977**
in London

1997–2000
Kingston University, London

Nick Relph
Born in **1979**
in London

1998–2000
Kingston University, London

Selected Solo Exhibitions
2005
Serpentine Gallery, London
Gavin Brown's enterprise, New York
2004
Kunsthalle, Zurich
The National Museum of Contemporary Art, Oslo

Selected Group Exhibitions
2005
Greater New York 2005, PS1, Long Island City, New York
2004
Sodio y Asfalto, Museo Tamayo Arte Contemporáneo, Mexico City
2003
Dreams and Conflicts – The Dictatorship of the Viewer, 50th Venice Biennale
Days Like These, Tate Triennial of Contemporary British Art, Tate Britain, London

Live and work in London and New York

Oliver Payne and Nick Relph
Pensions de Nocturno 2004
Ink jet print. Edition 6
29.8 x 21
Courtesy Herald St, London

OLIVIA PLENDER

Historical research is at the crux of Olivia Plender's practice. Her works investigate subjects that are idiosyncratic and little-known; peculiar pockets of forgotten history that sit awkwardly with the way we live now. One such preoccupation has been nineteenth-century spiritualism, a movement that offered entertainment as well as religion and provided a platform for working-class women to voice their own political opinions 'apparently' on behalf of the spirits of the dead. More recently, Plender has been fascinated by outlandish filmmaker Ken Russell and by the Kindred of the Kibbo Kift, a strange camping cult set up in the 1920s by artist and renegade boy-scout leader John Hargrave. Despite the diversity of such points of departure, recurring themes in Plender's work stand out: non-conformism, the notion of genius, and the incongruous clash between spiritual idealism and the commonplace expediency demanded by the world.

The Masterpiece 2002–, an ongoing, pencil-drawn comic set in an imaginary 1960s avant-garde London, combines many of Plender's interests. It follows the travails of Nick, an artist labouring under the burden of genius as he strives to create the masterpiece he is destined to make. Borrowing the title from a novel by Emile Zola of 1886, and culling text and images from a wide range of sources – pulp-fiction, films, adverts, interviews, comic culture, novels and art history – Plender's *Masterpiece* is a beautiful hotchpotch of appropriation, whose form riffs on and rebukes the Romantic views of art production espoused by her hero Nick.

One of the sources for the comic's narrative is an interview that Ken Russell gave, in which he talked about the artist Henri Gaudia-Brzeska, the subject of his film *Savage Messiah* 1972: 'you imagine that you're going to suffer, toil away unrecognised for years, and then suddenly one day you're

Born in 1977
in London

1995–1998
Central Saint Martins College of Art and Design, London

Selected Solo Exhibitions

2005
The Medium and Daybreak, Castlefield Gallery, Manchester

Dance of the Seven Veils, Cooper Gallery, Dundee

A Public Meeting to Address the Phenomenon of Materialisation as part of Man in the Holocene, London (performance)

Selected Group Exhibitions

2005
Paris–Londres: Le voyage Interieur, Espace Electra, Paris

IX Baltic Triennale of International Art, Contemporary Arts Centre (CAC), Vilnius, Lithuania

A Gathering of Merrie Campers, collaboration with Ken Russell as part of Coniston Water Festival, Grizedale Arts (performance)

2004
Romantic Detachment, PS1, New York

East End Academy, The Whitechapel Gallery, London

Lives and works in London

going to be discovered ... he knew he was good. He knew he was a genius.' Fascinated by the construction of personal narratives through clichés, Plender has befriended Russell, and has woven performances around his persona. Recently they worked together on a re-enactment of a Kibbo Kift ceremony set in the Lake District entitled *A Gathering of Merrie Campers* (Grizedale Arts 2005). In contrast to other artists exploring early modernist utopianism, the history that Plender plunders is banal and baffling, the stuff of suburban revolutionaries whose idealism is mitigated by nostalgia for an England of yore and an entrenched middle-class conservatism.

Underpinning Plender's work is a determination not to make art that is determined by form and commodity. Instead her work is varied and responsive, manifesting itself as drawing, comic-book, magic show, performance, text, film, and often creating channels for other people's stories. Repeatedly the medium is displaced: Ken Russell's words are given to Nick the comic-book hero to say; a cult leader from the 1920s is resurrected in the form of Russell; and Spiritualists of centuries ago are mediums for the thoughts of others beyond the grave. This accumulative layering of personalities, real and fictional, highlights just how much our sensibilities have changed from those of previous generations, and how much both societies and individuals fabricate their own characters out of the stories of others.

Gair Boase

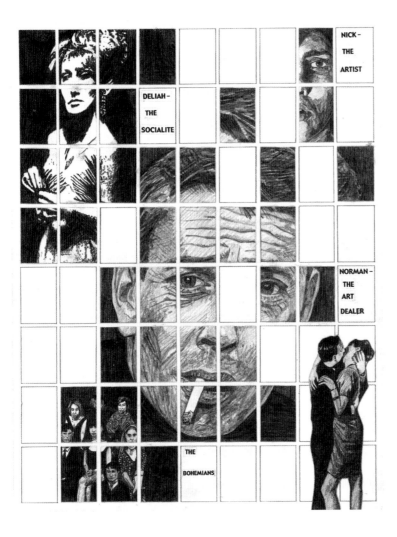

NICK –
THE
ARTIST

DELIAH –
THE
SOCIALITE

NORMAN –
THE
ART
DEALER

THE
BOHEMIANS

Olivia Plender
Masterpiece 2002–
Pencil on paper. 29.5 x 21
Courtesy the artist

MUZI QUAWSON

The photographer Muzi Quawson documents people and communities. She explores different aspects of American society and the various social, financial and political structures that define it. Her work has focused on a broad spectrum of contemporary life: from being commissioned by the *Guardian* newspaper to photograph a multi-generational household in Georgia, made up of different political persuasions, in the run-up to the 2004 Presidential Election, to the representation of youth culture in the suburbs of Buffalo and Seattle.

After a chance meeting in Manhattan in 2002, Quawson became friends with Amanda Jo Williams, who invited her to stay with her family in the bohemian town of Woodstock, Upstate New York. The town's name is synonymous with the Woodstock music and arts festival of 1969 – a free event that brought together nearly 400,000 people in a celebration of peace and love. This event has been romanticised and idealised in American popular culture as the culmination of the hippy movement. Nearly forty years later, the festival's mythical resonances continue to permeate the municipality and inform the lifestyles of its inhabitants, including Williams. *Pull Back the Shade* 2002-2006 is a pictorial journey, documenting with total candour Williams' relationship with her partner and young twin daughters. Quawson's images encompass the scope of her subject's life from hanging out at home to road trips made with friends. She draws on the cinematography of New American Cinema of the 1970s and its use of outsider anti-heroes, and unusual camera and editing techniques. In particular Quawson has been heavily influenced by Martin Scorsese's *Taxi Driver* 1976 and *Raging Bull* 1980 and their impact on more recent film makers such as Gus Van Sant (*My Own Private Idaho* 1991) and Vincent Gallo (*Buffalo '66* 1998).

A prolific photographer, Quawson edits her images to focus both on the individual and on wider

Born in 1978
in London

2004–2006
Royal College of Art, London

1998–2001
Kent Institute of Art and Design, Canterbury

Selected Group Exhibitions

2005
Bloomberg New Contemporaries,
Cornerhouse, Manchester

Lives and works in London

thematic issues. While fascinated by Williams' alternative lifestyle, rooted in a political and intellectual tradition that harks back to the 1960s, there is also a sense that Williams is living in what she herself has described as 'a haze'. The resulting photographs, presented as a slide show, offer a compelling commentary on the frustrations of young motherhood, domesticity and social alienation. If the clicking of the carousel evokes the sound of a camera-release, the medium's transparency and temporal qualities shift the image beyond the conventional parameters of the frame towards the cinematic. Operating in the gap between photography and film, as T.J. Demos has described, the slide-show functions across 'an indeterminate zone, between the autonomy of the single-frame photograph and the uninterrupted continuity of the filmic allusion'.[1] By culminative effect, the pictures achieve something approaching a narrative, but there is no sense of dramatic incident. Instead they function as a quiet contemplation on the nature of identity.

Clarrie Wallis

Muzi Quawson

Union City Blues, Brooklyn,
New York, USA, July 2004

Slide from *Pull Back*
***the Shade* 2002–2006**
35 mm slide projection
Courtesy the artist

Muzi Quawson
Pull Back the Shade 2002–2006
35 mm slide projection
Courtesy the artist

(Clockwise from top left)
At Lisa Smallwood's House,
Georgia, USA, May 2004
Breakfast Tea, Woodstock,
New York, USA, June 2004
Performance, Woodstock,
New York, USA, July 2004
Stephen, Seattle, Washington,
USA, April 2004

Underground, Lower East
Side, New York, USA,
August 2002
Crème and Sugar, Brooklyn,
New York, USA, August 2002
Camper, Hudson Valley, New
York, USA, July 2004

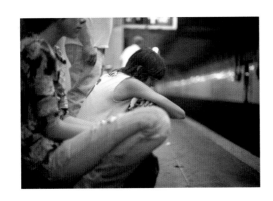

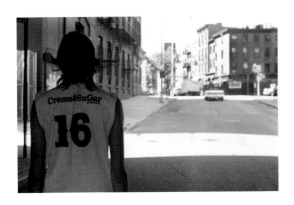

EVA ROTHSCHILD

Eva Rothschild creates objects that are immediately striking and unforgettable. Her geometric and abstract forms make an initial visual impact and then haunt the memory, prompting one to return to them again and again. Her sculptures are not, however, the products of a carefully distilled recipe, for there is no preconceived programme. They evolve intuitively, through an interaction between materials, processes and ideas, the outcome of which is an entity that may have been partially known beforehand but was never wholly predictable.

More than many of her contemporaries, Rothschild is engaged with enduring sculptural issues, working with materials such as leather, wood and Plexiglas. Questions concerning the possible relationships between volume and mass, skin and structure, surface and edge have been explored in different ways, as a comparison between *Stalker* 2005 and (*Knock Knock*) 2005 demonstrates. If *Stalker*'s open and closed geometric aspects suggest a desire to create an object that somehow balances volume and space, recent, more linear works articulate this in a new way. Neither figurative nor abstract, (*Knock Knock*) succeeds in taking up space without volume. Its organic appearance is reminiscent of a branch or a bolt of lightning hitting the ground.

Rothschild likes to vary the materials and methods she uses, uniting incongruous materials in different ways. *Silly Games* 2003, for example, juxtaposes carefully woven leather hoops with ceramic. Elsewhere industrial materials are combined with craft elements that are very much concerned with the handmade, with intimate and physical processes, often involving special dexterity. As Rothschild explains: 'I like using craft methods because it aligns [my sculptures] closely with me as the maker. Craft is something that has been sanitised by mass production, the handcrafted object has become a symbol of quality and luxury

Born in **1972**
in Dublin

1997–1999
Goldsmiths College,
University of London

1990–1993
University of Ulster, Belfast

Selected Solo Exhibitions

2005
Douglas Hyde Gallery, Dublin

Modern Art, London

2004
Kunsthalle Zurich

Heavy Cloud, The Modern
Institute, Glasgow

2000
Peacegarden, The
Showroom, London

Selected Group Exhibitions

2005
British Art Show 6, Hayward
Gallery Touring

Extreme Abstraction,
Albright-Knox Museum,
Buffalo, USA

2004
54th Carnegie International,
Carnegie Museum of Art,
Pittsburgh, USA

2003
*My Head is on Fire but
my Heart is Full of Love*,
Charlottenberg, Copenhagen

Lives and works in London

whereas craft techniques actually sprang from real necessity.'[1]

Certain aspects of Rothschild's thinking, including her interest in elemental forms and a conviction that material must be engaged with rather than dictated to, seem to position her interests close to debates about the sculptural object that prevailed in the 1960s. Yet the impact of Rothschild's work resides not only in formal and material considerations. It also derives from the abstraction and appropriation of different visual codes and images that are remixed to create contemporary totems. Her iconography is informed by everyday experiences and travels, by seeing things in the world, such as eighteenth-century astronomical observatories in India. Her highly personal sculptural language is inspired by contemporary culture – music, film, literature – and by religion. She is particularly interested in the way in which objects have a power over us, especially in relation to religious thought or superstition. This is reflected in her fascination with signs and symbols, sacred or lucky objects. These range from forms such as spheres and pyramids to New Age charms and the Canopic jars found in ancient Egyptian tombs. In this way, competing rather than connecting influences are combined to create hybrid forms that explore how we ascribe meaning to things.

Clarrie Wallis

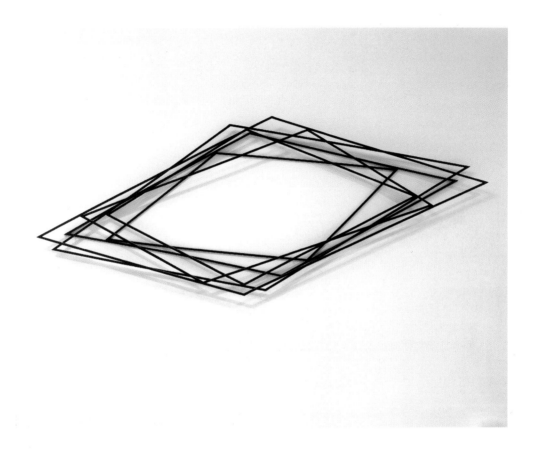

Eva Rothschild
Jealous Sea **2004**
Wood. 110 x 250 x 25
Private Collection, London
Courtesy the artist and
The Modern Institute, Glasgow

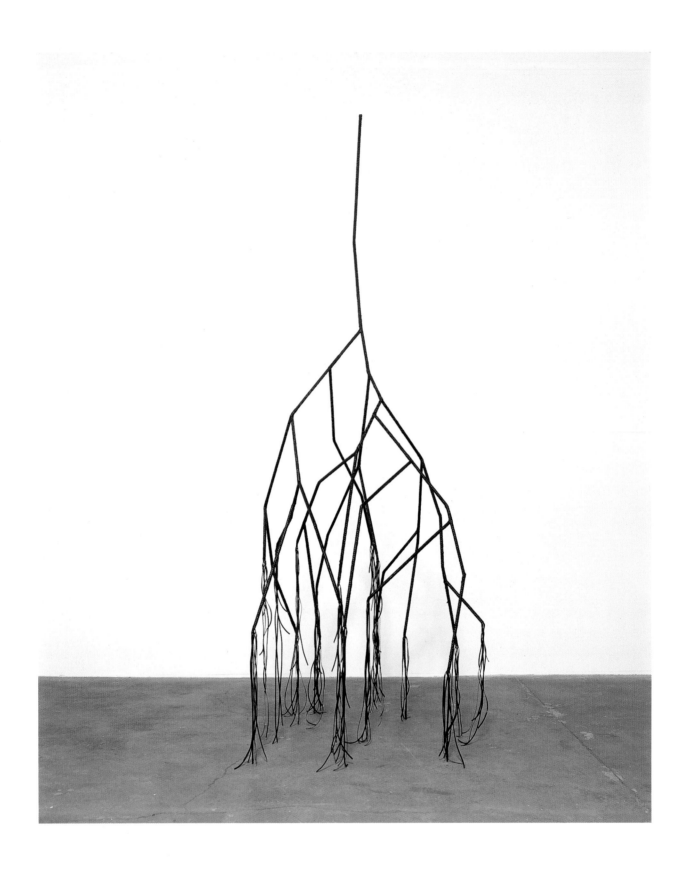

Eva Rothschild
Knock Knock 2005
Leather, steel support
140 x 289 x 130
Courtesy Modern Art, London and
The Modern Institute, Glasgow

30

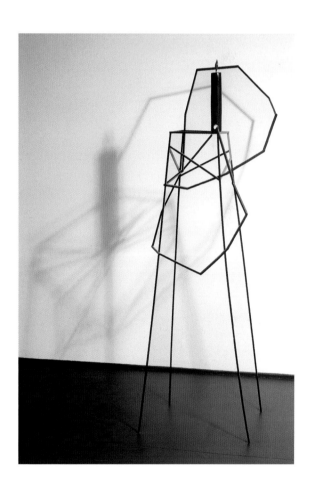

Eva Rothschild
Light to Light 2005
Wood, jasmonite, paint
210 x 75 x 90
Courtesy the artist and The Modern
Institute, Glasgow

TINO SEHGAL

Tino Sehgal's practice operates at the thinnest boundary between art and life: in the artist's specific adjustment of a person's, or group of people's, speech or gestures. Sehgal works with amateur actors whom he labels as 'interpreters'. He inserts simulacral gallery guards or people in ordinary clothes, whom we might mistake at first for fellow gallery-goers, into exhibition spaces and instructs them to make certain movements or engage in directed patterns of dialogue. *This Objective of that Object* shown at the ICA, London, 2005 was a piece executed by a cast of five people in continuous rotation and comprised a complicated sequence of words and actions activated by the new arrival of each visitor into the space. The physical behaviour and response or engagement of the spectator fed into the direction this mutable routine would take, assertively conforming to the dictum that you get out what you put in. *This is Right*, presented by The Wrong Gallery at Frieze Art Fair, London, in 2003, involved the participation of two child actors who explained five of Sehgal's pieces, offering them for sale. The pieces included *This is Good* 2001, *This is New* 2003 and *This is Exchange* 2003, in which they demanded opinions on the market economy from shrinking visitors. Against the professional and artificial atmosphere of the brightly lit, air-conditioned fair they appeared at once superreal and disruptively parodic. The grown up business transactions in the surrounding booths began to seem childish in comparison to their initiation of analytical dialogue, a sense tempered only by the occasional rivalrous tantrum between the pair.

Wishing to distance his work from ideas of 'performance' and 'live art' associated with body-centred authenticity, Sehgal prefers to see his pieces as forms of sculpture. Recently acquired by verbal contract for Tate, his sung piece executed by a single interpreter titled *This is Propaganda* 2002 will be installed for the *Tate Triennial* among

a collection display. *Instead of allowing some thing to rise up to your face dancing bruce and dan and other things* 2000, presented also in his 2005 ICA show, resists the idea of energetic liveness, and pulls against performance history's fetishisation of climactic moments captured by the camera. Pulling against the modernist logic of the white cube space the piece seemed to register the death throes of the performance genre; its reification in black and white documentary photography made impossible to grasp. Like a stitched together series of bad blurred photos from art history, rather than a clear indication of live human presence, the dancer's slow movements appeared as a kind of smear or stain.

Slipping in and out of explicit visibility, all of Sehgal's pieces insert themselves into gallery situations as manipulations of, or elaborations on, the everyday encounter. The work plays upon an in-built, reflexive mode of perception inside the museum or gallery that is conceptual art's legacy. In the simplest sense, the heightened awareness that the work brings crystallises, and makes strange, our experience of a passage of time, foregrounding the act of viewing and doubling it back so that the spectator is placed within the frame. Familiar economies of language and gesture are disrupted in Sehgal's work so as to point outside of the dynamics of habitual interaction and etiquette – combining ordinary social and gallery-specific protocols to facts of history and politics as well as to the repressed psychological dynamics at stake.

Catherine Wood

Born in **1976**
in London

Selected Solo Exhibitions

2005
ICA, London

2004
Van Abbemuseum, Eindhoven

This is Competition, Art Basel, Switzerland

2003
This is Right, Wrong Gallery, Frieze Art Fair, London

Selected Group Exhibitions

2004
Ailleurs, ici, Musée d'Art Moderne de la Ville de Paris

2003
Utopia Station: Dreams and Conflicts – The Dictatorship of the Viewer, 50th Venice Biennale

2002
I Promise it's Political, Museum Ludwig, Cologne

2001
A Little Bit Of History Repeated, Kunst-Werke, Berlin

Lives in Berlin

Une civilisation complète devra se faire, où toutes les formes d'activité tendront en permanence au bouleversement passionnel de la vie.

De ce *problème des loisirs*, dont on commence à parler alors que les foules sont à peine libérées d'un travail ininterrompu — et qui sera demain le seul problème — nous connaissons les premières solutions.

Cette grande civilisation qui vient *construire des situations et des aventures*. Une science de la vie est possible. L'aventurier est celui qui fait arriver les aventures, plus que celui à qui les aventures arrivent. L'utilisation consciente du *décor* conditionnera des comportements toujours renouvelés. La part de ces petits hasards qu'on appelle un destin ira diminuant. A cette seule fin devront concourir une architecture, un urbanisme et une expression plastique influentielle dont nous possédons les premières bases.

La pratique du dépaysement et le choix des rencontres, le sens de l'inachèvement et du passage, l'amour de la vitesse transposé sur le plan de l'esprit, l'invention et l'oubli sont parmi les composantes d'une *éthique de la dérive* dont nous avons déjà commencé l'expérience dans la pauvreté des villes de ce temps.

Une science des rapports et des ambiances s'élabore, que nous appelons *psychogéographie*. Elle rendra le jeu de société à son vrai sens : une société fondée sur le jeu. Rien n'est plus sérieux. Le divertissement est bien l'attribut de la royauté qu'il s'agit de donner à tous.

Le bonheur, disait Saint-Just, est une idée neuve en Europe. Ce programme trouve maintenant ses premières chances concrètes.

L'attraction souveraine, que Charles Fourier découvrait dans le libre *jeu des passions*, doit être constamment réinventée. Nous travaillerons à créer des désirs nouveaux, et nous ferons la plus large propagande en faveur de ces désirs.

Nous sommes ceux-là qui apporterons aux luttes sociales la seule véritable colère. On ne fait pas la Révolution en réclamant 25.216 francs par mois. C'est tout de suite qu'il faudrait *gagner sa vie*, sa vie entièrement terrestre où tout est faisable :

On ne saurait rien attendre de trop grand de la force et du pouvoir de l'esprit.

Paris, le 5 mai 1954.

Pour l'Internationale Lettriste :

Henry de BEARN, André CONORD, Mohamed DAHOU,
Guy-Ernest DEBORD, Jacques FILLON,
Patrick STRARAM, Gil J. WOLMAN.

JOHN STEZAKER

John Stezaker has long held a fascination for the arresting power of images. In the early 1970s, a period when the detached and self-referential investigations of Conceptualism and Minimalism still dominated, this was a radical interest. Influenced by the political and social changes following the upheavals of May 1968, as well as the Situationist writings of Guy Debord, he became a leading exponent of a move to develop art that engaged with its own place in the real world. Embracing rather than avoiding the ubiquitous presence of the mass media through TV, advertising, films, commercial publishing, etc, he set out to question the authority of the photographic print through a direct intervention into its homogenous and ordinary status. By inverting, cutting, tearing or gluing an image taken from film, art-history books, magazines, catalogues, postcards, or encyclopaedias, he embarks upon 'a process that cuts it off from its disappearance into the everyday world'.[1] Stezaker imbues his work with a transcendent and psychic charge through the simple, hand-crafted act of splicing unrelated fragments together or inverting unremarkable scenes. Despite the apparently unsophisticated nature of their construction, these hybrid cut-outs appear seamless.

Since its invention in 1912 as part of the Cubist revolution, collage has been employed by a succession of artists, from Hannah Höch, with her Surreal photomontages, to Joseph Cornell's playful assemblages. This technique of papier collé exposes the illusionist nature of pictures, representing the fragmented experience of the world through a process of deconstruction and reassemblage to suggest a strange and disjointed reality. The Duchampian concept of the 'found image' is vital to this act of disjunction: for Stezaker the image is not the result of a specific search or idea, but is happened upon, in a process that 'puts the image on equal terms with your own subjectivity'.

Born in 1949
in Worcester

1967–1973
The Slade School of Art, London

Selected Solo Exhibitions

2006
White Columns, New York

2005
Kunstverein, Munich

2004
The Third Person Archive and Other Works, The Approach, London

1996
Garden, Cubitt, London

1983
Lisson Gallery, London

Selected Group Exhibitions

2005
Girls on Film, Zwirner & Wirth, New York

2004
Collage, Bloomberg Space, London

2000–2001
British Art Show 5, Hayward Gallery Touring

1982
Aperto, 40th Venice Biennale

1972
The New Art, Hayward Gallery, London

Lives and works in London

Discussing Duchamp's use of words such as 'arrest' or 'stoppage' to describe the act of finding and extracting an image, he comments, 'I pick up on that moment of interruption; I see the cut as a decisive interruption of the flow, whether it's the flow of cinema and the film still or image turnover and circulation.' Yet Stezaker's selection is driven by a vision more romantic than Duchamp's deliberately provocative extraction of mundane objects from the realm of the everyday.

In an ongoing series, collectively titled *Masks* 2005, postcard scenes of romantic pastoral landscapes obscure various portraits of 1950s film stars. These playful works have a strong dreamlike or uncanny quality, reminiscent of subversive and disturbing Surrealist works. Another series, *City* 2000–2004, reveals the inherent strangeness of urban living, making only the simple and discrete intervention of inverting a cityscape to detach the image from its everyday anonymity. A mundane photograph of anonymous buildings and streets is made magical simply by becoming a reflection of itself. In his latest group, *Reparations* 1999–2005, Stezaker makes a simple adjustment to the angle of the selected photograph and in doing so rights a fallen tree or electricity pylon in a poignant attempt at a form of repair or amendment through the power of the image.

Katharine Stout

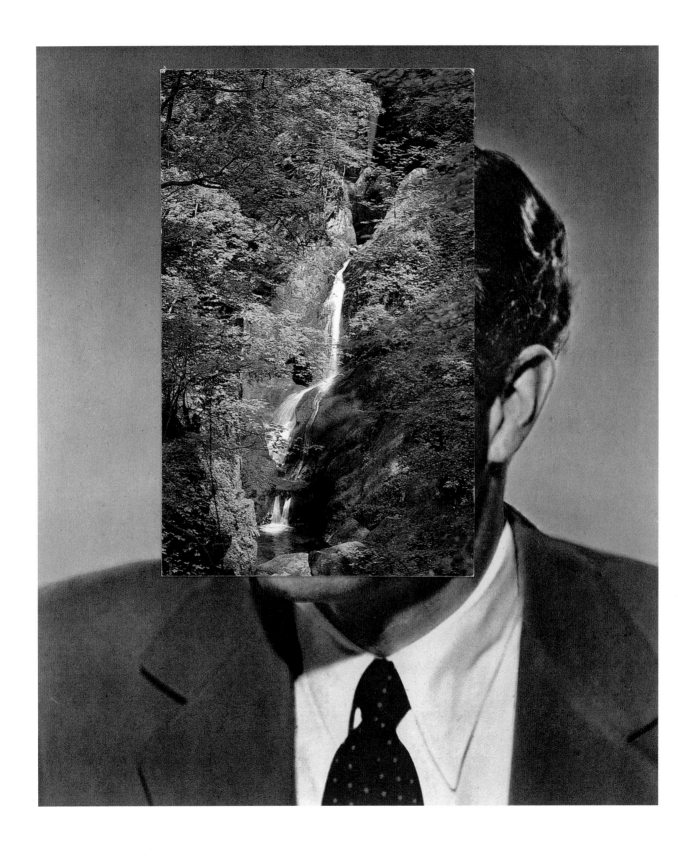

John Stezaker
City I
2000–2004
Found photographic
image. 4.3 x 5
Courtesy the artist and
The Approach, London

32

John Stezaker
Reparation I
1999–2005
Found photographic image
11.7 x 12.7
Courtesy the artist and
The Approach, London

REBECCA WARREN

Rebecca Warren's work challenges the status of sculpture. Fashioned from unfired clay, her exuberant female forms question assumptions about the use of materials and our understanding of the figurative ideal. Malleable, expressive and unpredictable, clay is an inherently subversive material. It has been overlooked as a medium precisely for the properties that make it so attractive to Warren. Its playful, democratic nature may account for its exclusion from traditional histories of art and accounts of modernism. Indeed, the American critic Hilton Kramer described the 'high unseriousness' of artists working in clay, consigning such works to the status of non-art or craft.[1] Nevertheless, the German Expressionists, the Fauves and artists such as Pablo Picasso, Joan Miró, Isamu Noguchi and Lucio Fontana all made works in clay. In *Rose Garden* 2004, one of a series of small-scale, plinth-based works, there are echoes of Fontana's early sculptures, in particular his polychromatic sculptures of the late 1930s. While Warren taps into this neglected history, her use of clay signals a concern with the materiality of sculpture. Simply left to dry, the roughly modelled figures are made from clumped pieces of clay. Although there is clearly an element of working and reworking of form – of revision and effacement – the overall feel is of primeval vitality.

Collectively entitled *She* 2003, Warren's voluptuous figures have grossly exaggerated breasts and buttocks that are reminiscent of Mesopotamian fertility figurines. Highly sexualised, their striding poses and comical high heels reinforce clichés of male voyeurism. Warren draws from a variety of sources, from Degas to Helmut Newton and Robert Crumb, from books, magazine photographs and popular culture in general, and she openly acknowledges these references. As she explains, 'It's about finding a way to be expressive. Expression is perceived as a problem.

Born in **1965**
in London

1992–1993
Chelsea College of Art,
London

1989–1992
Goldsmiths College,
University of London

Selected Solo Exhibitions
2005
Pas de Deux, Matthew Marks
Gallery, New York

Galerie Daniel Buchholz,
Cologne
2004
Dark Passage, Kunsthalle
Zurich
2003
Donald Young Gallery,
Chicago

SHE, Maureen Paley Interim
Art, London
2000
The Agony and the Ecstasy,
Maureen Paley Interim Art,
London

Selected Group Exhibitions
2005
Drunk & Stoned, Gavin
Brown's enterprise, New
York

British Art Show 6, Hayward
Gallery Touring

Translations, Thomas Dane
Gallery, London

Body: New Art from the UK,
Vancouver Art Gallery
2004
*Sculpture, Precarious
Realism between the
Melancholy and the Comical*,
Kunsthalle Vienna

Lives and works in London

One way of negotiating that is to reuse existing idioms that are accepted as being expressive, for instance Auguste Rodin, Willem de Kooning or Otto Dix.'[2] If she questions the politics of representation and sexual stereotypes, she does so in a way that is deliberately ambiguous.

Part of the strength of these works is Warren's use of the grotesque. Unlike the ordered, ideal, classical body, the grotesque body is in Mikhail Bakhtin's influential formulation, 'not a closed, complete unit' but 'transgresses its own limits'.[3] Emphasis is on 'apertures or the convexities ... the open mouth, the genital organs, the breasts, the phallus, the pot-belly or the nose'. The grotesque has always been strongly associated with ludicrous exaggeration or distortion. It is radical and extravagant – an unresolved clash of incompatibles. Thus Warren's complex mobilisation of influences, loaded with references and visual resonance, can be understood as exuberant celebrations of materiality.

Clarrie Wallis

Rebecca Warren
Cube 2003
Bronze, MDF and wheels
51 x 35 x 37.5
The Cranford Collection, London
Courtesy Maureen Paley

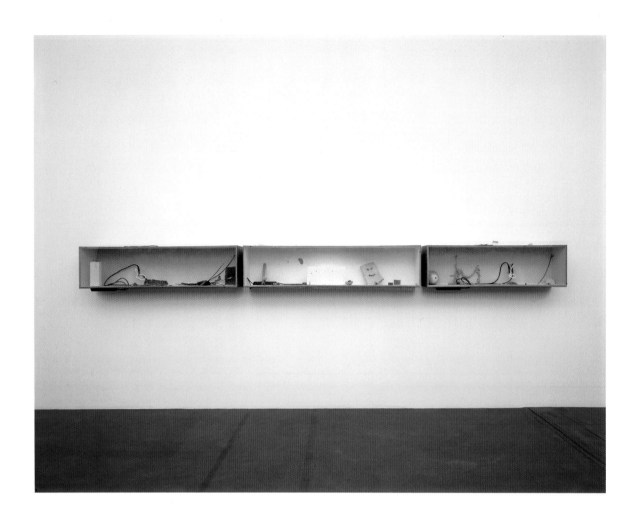

Rebecca Warren
*I love the sound of
breaking glass* 2004
Mixed media
43 x 18 x 31 (x 3)
Dimitris Daskalopolous Collection,
Greece
Courtesy Maureen Paley

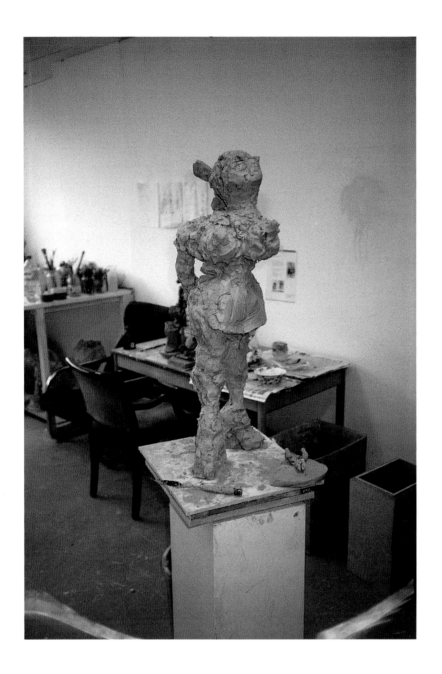

Rebecca Warren
Bunny 2002
Reinforced clay and plinth
73.5 x 38 x 34.4
Collection of Donald and
Shirley Young
Courtesy Maureen Paley

33

NICOLE WERMERS

Nicole Wermers' sculptures, collages and architectural structures combine formal aspects of modernism with the high end of capitalist consumerism. Visually seductive, the work obliquely references the elements that surround and shape our everyday experiences, from design, advertising and the media to architecture and the urban environment. Wermers is particularly drawn to inconspicuous backgrounds, thresholds or 'in-between spaces' and the role they play in contemporary life. These range from the lobby, within which one can imagine encountering one of her 'ashtray' sculptures, to department-store entrances, whose shoplifting detectors have provided the inspiration for steel gate-like structures such as *Untitled* 2004. Elsewhere, the settings within which luxury goods are photographed for glossy magazines have formed the basis for a series of small abstract collages (1998–). Having carefully cut out the object of desire, she uses the backgrounds of the advertisements to create equally seductive, complex forms that recall Geometric Abstraction. Through the arrangement of tonal graduations, varying kinds of textures and linear points of focus, Wermers creates dynamic compositions that are both pictorial and sculptural and offer a feeling of expansive abstract space. As she explains, 'What remains of the original material is the means and the effect, which opens up a new space.'[1]

The sense of making or reclaiming alternative spaces is also present in an early video, *Palisades* 1998, of an upside-down camera ride across the ceilings of corporate foyers and hotel lobbies, as well as in her small-scale models. These imaginary spaces range from modern churches to decommissioned shop interiors. In *Nieuwe Kerk (New Church)* 2002, Wermers combines the stylistic qualities of modernist architecture with building materials – wood, concrete, aluminium and glass. In these works she is interested in exploring architectural

language, intended to communicate a particular vision, be it sacred or secular. In *Vacant Shop I* 1999, another in-between space, the attractions and surfaces of contemporary consumer culture are recreated to produce 'a formal playground' that reads simultaneously as architectural model and abstract sculptural form.

French Junkies 1–11 2002 is a series of freestanding ashtrays. Implicit within these works is a sense of ambiguity towards reference and representation. Loaded with art-historical allusions but topped with clean sand, as if intended for immediate use, these objects deliberately call their own status into question. In *French Junkies 6 and 10* the arrangement of different elements brings to mind the formal experiments of Russian Constructivists such as Alexandro Rodchenko, Lazar El Lissitzky or Katarzyna Kobro, whereas *Untitled (Ashtray)* 2005 directly references Constantine Brancusi (1876–1957), one of the founding figures of modern sculpture.

Formalism is not the main topic at stake in these works, however. Wermers is fascinated by the aura of objects, and by the strategies based upon this that shape modern consumer behaviour and the aesthetic encounter. This sense of the object's fetishistic aura is further highlighted by a recent sculpture, *Untitled (Forcefield)* 2005. Consisting of two freestanding steel rings positioned in relation to one another, both its form and its title are suggestive of an invisible force surrounding the object. In connecting the experimental dimension of formalist art with the idea of consumerist luxury and desire, Wermers creates a highly personal critique of contemporary reality, where questions of form, experience and context may once more be negotiated.

Clarrie Wallis

Born in 1971
in Emsdetten, Germany

1999
Central Saint Martins College of Art and Design, London

1990–1997
Hochschule für bildende Künste, Hamburg

Selected Solo Shows

2006
Herald St, London

2004–2005
Chemie, Secession, Vienna

2004
Katzensilber, Millers Terrace, London

2002
French Junkies, Produzentengalerie, Hamburg

Selected Group Shows

2006
The Insidious Charm of the Bourgeoisie, Van Abbemuseum, Eindhoven

2005
Alles in einer Nacht, Tanya Bonakdar Gallery, New York

2004
The Future has a Silver Lining, Migros Museum, Zurich

2004
Pin Ups, Contemporary Collage and Drawing, Tate Modern, London

2001
Szenenwechsel XX, Museum für Moderne Kunst, Frankfurt

Lives and works in London

Nicole Wermers
Untitled 2005
Collage. 36 x 26
Collection Jerome and
Ellen Stern
Courtesy the artist

34

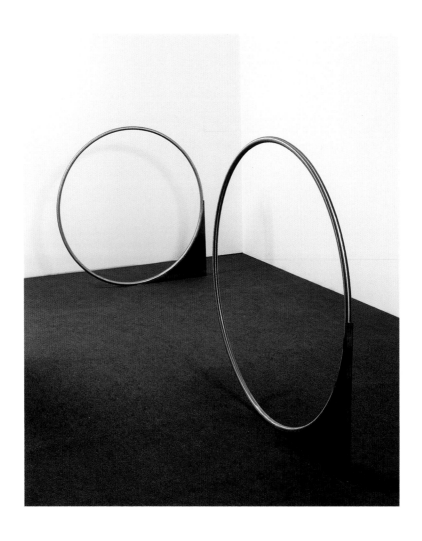

Nicole Wermers
Untitled (Forcefield) **2005**
Steel. Dimensions variable
Courtesy Herald St, London

Nicole Wermers
Untitled (Ashtray) 2005
Steel, plastic, lacquer, sand
85 x 28 x 28
Collection Yana and Stephen Peel
Courtesy the artist

CERITH WYN EVANS

The main constituents of Cerith Wyn Evans' art – language and light – are transient and elusive, setting the atmospheric tone for his diverse and captivating works. Morse code, the now redundant binary system of communicating text through sound or light, is therefore the perfect vehicle for the artist. Fireworks are another medium he employs, offering a similar sense of urgency and drama to his carefully constructed mise-en-scènes. For his 16mm film *Firework Text (Pasolini)* 1998, Wyn Evans placed a construction on Ostia beach near Rome that spelled out in fireworks a line from Pier Paolo Pasolini's film *Oedipus Rex* 1967: 'On the banks of the Livenza / silvery willows are growing / in wild profusion, their boughs / dipping into the drifting water.' Against the sea and night sky the words, describing the idyllic landscape that Pasolini knew as a child, go up in flames on the same desolate beach where he was murdered in 1975.

The idea of working with Morse code and encryption came from Wyn Evans' experiences of visiting Japan. He comments on the impact of his first stay in Tokyo and looking out of a skyscraper at a huge sea of flickering lights: 'I thought, if only I could tune in to what the city was saying, then there would be this vast, dense polyphony of texts that are all somehow speaking at the same time ... the city became this vast coded matrix of texts.'[1] In *Cleave 00* 2001, a displayed lap-top computer translates the complete poetry of William Blake into Morse code, which is then projected by means of a theatrical spotlight onto a huge mirror ball, where it splinters into thousands of shards of light. Encrypted in secrecy, Blake's mystical poetry pulses out, creating a magical hybrid between a celestial sky and a disco dance floor. The Venice Biennale became the dramatic stage-set for *Cleave 03* 2003, commissioned by the Welsh Pavilion, in which a World War II searchlight beamed out into the night sky the canonical Welsh text, *Gweledigaethau y*

Born in **1958**
in Llanelli, Wales

1984–1987
Royal College of Art, London

1980–1983
St Martins School of Art, London

Selected Solo Exhibitions
2005
Once a Noun, Now a Verb ..., Galerie Neu, Berlin

299792458m/s, BAWAG Foundation, Vienna

2004
Thoughts unsaid, not forgotten ..., MIT Visual Arts Centre, Boston, USA

Museum of Fine Arts, Boston, USA

Kunstverein, Frankfurt, Germany

2003
Look at that picture ... How does it appear to you now? Does it seem to be Persisting?, White Cube, London

2000
Art Now, Tate Britain, London

1998
Centre for Contemporary Art, Kitakyushi, Japan

Selected Group Exhibitions
2005
The Vanity of Allegory, Deutsche Guggenheim, Berlin

2004
Modus Operandi, Thyssen-Bornemisza Art Contemporary, Vienna

2003
Further: Artists from Wales and *Utopia Station: Dreams and Conflicts – The Dictatorship of the Viewer*, 50th International Venice Biennale

Adorno, Kunstverein Frankfurt

Lives and works in London

Bardd Cwsc (Visions of the Sleeping Bard) 1703, by Ellis Wynne. The signal was transmitted towards another lightbulb located across the city, which 'read' out the Spanish book, *Suenos y Discursos* (Dreams and Discourses) 1627 by Francisco de Quevedo, from which Wynne's text was adapted. For Wyn Evans, 'The real work is situated somewhere between these two points ... it's a piece about translation and translocation, ultimately.'[2]

Though comprising few elements, Wyn Evans' work is decadent and intense, both experientially and referentially. He is attracted by excess, quoting in an interview 'exuberance is beauty' from George Bataille's *The Accursed Share* 1998, in turn a quote from Blake.[3] Approaching knowledge like a magpie, he is confident that the combined effect of his recontextualised texts by authors of the past will be to invigorate our perception of the present. Wyn Evans paradoxically makes these texts accessible while simultaneously rendering them illegible through encryption. Deftly and succinctly, he creates both a rich phenomenological experience and an imaginary conceptual space for work that contains the ghostly presence of borrowed voices and ideas.

Katharine Stout

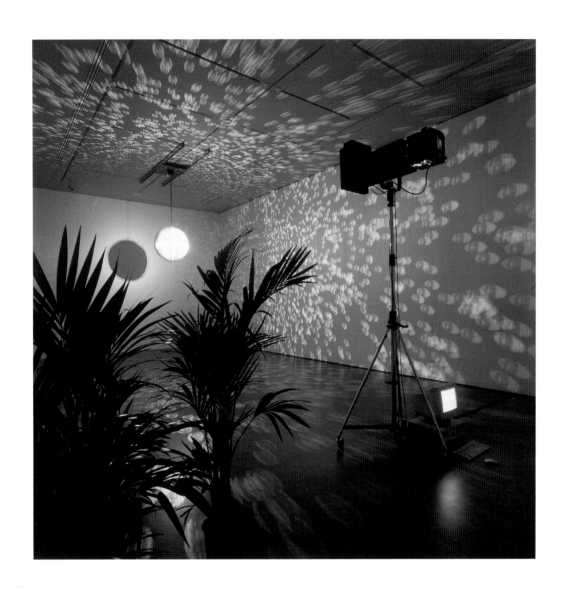

Cerith Wyn Evans
Cleave 00 2000
Mirror ball, lamp, shutter,
computer, text by William
Blake, plants
Dimensions variable
Courtesy Jay Jopling / White Cube
(London)

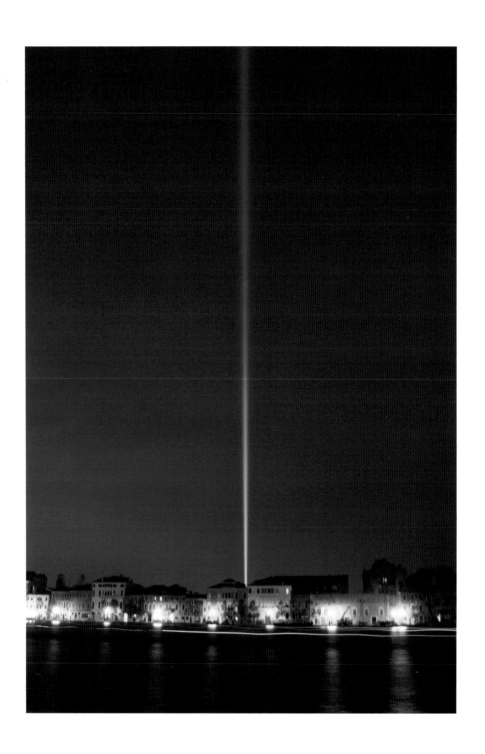

Cerith Wyn Evans
Cleave 03 (Transmission: Visions of the Sleeping Poet) 2003
World War II searchlight, shutter, computer, Morse code controlling device, text by Ellis Wynne
Dimensions variable
Courtesy Jay Jopling / White Cube (London)

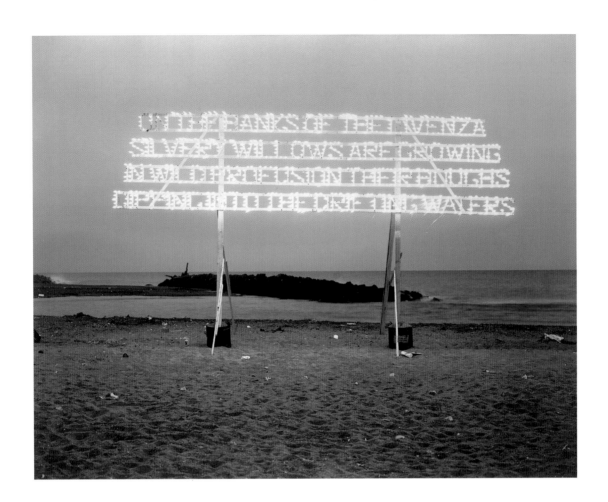

Cerith Wyn Evans
Firework Text (Pasolini) 1999
Five R-type colour prints
Each 36.5 x 38.5
Courtesy Jay Jopling / White Cube
(London)

THEATRE PIECES

In his essay, 'Theater, Cinema, Power'[1], the artist Dan Graham analyses the development of the theatre venue from an open amphitheatre in classical times to an enclosed architectural form during the Renaissance. The artist links this development to the codification of laws of perspective and the political emergence of the bourgeois city-state in Europe at this time. Graham looks specifically at the hierarchies at stake in the arrangement of fixed seating, and the Baroque stage's deep perspectival illusionism, which determined a privileged, 'ideal' viewing point. He draws a macrocosmic parallel between this arrangement and the position of the Ducal palace overlooking the public plaza. He goes on to make a reverse analogy in modern times with the position of Ronald Reagan, then US President, who began his career as a film actor and now 'plays "himself" and speaks the views of power'[2] on an all-pervasively theatricalised world stage. The political drive of this essay had been provocatively anticipated by Graham's own blunt reversal of audience-performer relations in his theatre pieces made between 1972 and 1977 such as *Performer/Audience/Mirror* 1977, which involved the placement of a large mirror before an assembled crowd. Graham believed that this would lead viewers to see themselves as 'a public body (as a unity)', and would give the audience 'a power within the performance equivalent to that of the performer'.[3]

The artists presenting live work as a part of the *Tate Triennial* share interests in common with Graham's exploration of the relationship between performer and audience. Staging sculptural or pictorial tableaux and ritual happenings that focus on the temporary crystallisation of the collective gathering, they are concerned with an idea of performance as a reciprocal engagement between those who appear on stage and those who witness the event. Broadly speaking, the ways in which these live works are conceived link them more closely to the general idea of 'theatre' – whether medieval travelling players, Baroque courtly spectacle, collective Shaker rites or the twentieth-century West-End musical – than to the spontaneous experimentation associated with the body-centred legacy of 'performance art'. Their work is less concerned with a revelation of authenticity on the part of the performer than with the ways in which images, atmospheres, passages of time might be marked by a temporary grouping of people arranged into particular configurations and how the immediacy of personal subjectivity might be tested against pre-existing cultural forms.

In order to adequately represent the cross-disciplinary nature of work by artists included in the *Triennial*, our concern was to feature this live work as a central part of the exhibition. A key way of establishing its integral presence was to commission artist Pablo Bronstein and architect Celine Condorelli to collaborate on an intervention in the North Duveen galleries. Bronstein's work deals with the fictionalisation of space through architectural typologies whilst Condorelli's practice often investigates spectator relationships in the gallery, as evidenced in previous projects such as *I am a Curator* at the Chisenhale Gallery in 2004, or *Alterity Display* at Lawrence O'Hana also 2004. The resulting multi-functional structure proposes a dual publicness for the space: its neo-classical grandeur transformed as a plaza by day – with reading and documentary material about the exhibition, and as a navigation point with general information for visitors – and as a performance arena by night. Rather than determining a singular, ideal viewpoint, the elements of the structure as 'arena' make explicit a conflict between a privileged and a democratic distribution of viewing positions, this made explicit in the tension between the delineated 'void' marked out in the centre of the space and the high viewing platform suggested by the inaccessible balcony. The presence of furniture elements designed for the different activities that will take place further suggest ways in which people might inhabit or occupy the area, establishing a variety of possible relations and positions that are only activated when performers and visitors use the space.

Catherine Wood

150

Celine Condorelli
Theatre Pieces 2005
Pencil on paper
Courtesy the artist

*Coupe du theatre royal
de St. Charles à Naples* 1772
Encyclopedie Diderot
et d'Alembert

Pablo Bronstein
Concept for a Public Square
2005 (foreground)
Plywood, acrylic paint
Dimensions variable

Installation View, *'Emblematic
Display': London in Six Easy
Steps: Six Curators, Six Weeks,
Six Perspectives*, ICA, London,
2005

Courtesy Herald St, London and ICA,
London

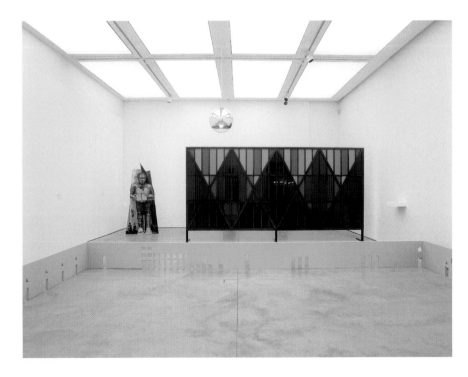

151

NOTES
LIST OF
EXHIBITED WORKS
AND
CREDITS

NOTES

REVISED NARRATIONS, BEATRIX RUF

1. Udo Kittelmann, 'Preface' in Sturtevant, *The Brutal Truth*, Museum für Moderne Kunst, Ostfildern-Ruit 2004, p.19.
2. Ibid., p.17.
3. Søren Kierkegaard, *Fear and Trembling / Repetition*, ed. and trans. Howard V Hong and Edna H Hong, Princeton 1983, p.149.
4. Ibid.

APROPOS APPROPRIATION, JAN VERWOERT

1. In this sense, the question *Que horas sont a Washington?* ('What times are it in Washington?') put forward by the singer and political activist Mano Chao, is the formula that sums up the current momentum. It does so through the purposeful misconstruction of the question in the plural – that is, through a moment of agrammatical slippage that Félix Deleuze described as crucial to a formula of resistance.
2. Douglas Crimp, 'Pictures', in Brian Wallis (ed.), *Art After Modernism: Rethinking Representation*, The Museum of Contemporary Art, New York, in association with David R. Godine, Boston 1984, pp.175–88 (reprinted from *October*, no.8 (Spring 1979)), pp.75–88; p.185.
3. Frederic Jameson, 'Postmodernism and Consumer Society', in Hal Foster (ed.), *Postmodern Culture*, London 1985, originally published as *The Anti-Aesthetic*, Port Townsend 1983, pp.111–25; p.118.
4. Ibid., p.115.
5. Ibid., p.114.
6. Craig Owens, 'The Allegorical Impulse: Toward a Theory of Postmodernism', in Brian Wallis (ed.), op. cit., pp.202–35 (reprinted from *October*, no.12 (Spring 1980), pp.67–86 and no.13 (Summer 1980), pp.59–80).
7. Ibid., p.212.
8. Douglas Crimp, op. cit., p.183.
9. Frederic Jameson, op. cit., p.120.
10. Edgar Allan Poe, *The Fall of the House of Usher* (1839), in Chris Baldick (ed.), *The Oxford Book of Gothic Tales*, Oxford 1992, pp.85–101, p.98.
11. Jacques Derrida, *Spectres of Marx*, New York and London 1994, p.132.
12. Ibid., p.xviii.
13. Ibid., p.176.
14. Ibid., p.175.

ANGELA BULLOCH

1. Video interview with Angela Bulloch for the *Preis der Nationalgalerie für Junge Kunst*, at the Hamburger Bahnhof, Berlin.

KAYE DONACHIE

1. Artist in conversation with author, 6 July 2005.

IAN HAMILTON FINLAY

1. Ian Hamilton Finlay in a letter to Yves Abrioux in 1983. All quotes taken from *Prints 1963-1997 Druckgrafick*, Ostfildern 1997.

MICHAEL FULLERTON

1. E-mail exchange between artist and author, 17 November 2005.

RYAN GANDER

1. E-mail exchange between artist and author.
2. Ibid.

LUCY McKENZIE

1. Lucy McKenzie and Paulina Olowska in conversation, Ujazdowski Park in Warsaw and via email, August 2003.

ALAN MICHAEL

1. Tom Morton on Alan Michael, *frieze*, issue 84, Summer 2004, pp.96–9.
2. Ibid.
3. Sturtevant in *Sliding Parameters of Originality*, from Original. Symposium Salzburger Kunstverein (ed.) Ostfildern 1995, p.142.

CHRISTOPHER ORR

1. Jean Baudrillarc, *Agony of the Real*, Berlin 1978, p. 7.

THE OTOLITH GROUP

1. This is a concept that The Otolith Group have developed following from Giorgio Agamben's reading of potentiality.

OLIVER PAYNE and NICK RELPH

1. Quote taken from 'Oliver Payne and Nick Relph talk about *Mixtape*, 2002 – A Thousand Words', *ArtForum*, September 2002 by Michael Wilson.
2. Quote taken from 'Oliver Payne & Nick Relph – 20 Questions', Matthew Higgs and Sarah McCrory, *Oliver Payne & Nick Relph*, Serpentine Gallery, 2005.

MUZI QUAWSON

1. T.J. Demos on 'Slideshow', *ArtForum XLIII*, May 2005, p.241.

EVA ROTHSCHILD

1. *Early One Morning*, Exh. Cat., Whitechapel Art Gallery, 2002.

JOHN STEZAKER

1. All quotes taken from 'Demand the Impossible', interview with Michael Bracewell and John Stezaker in *frieze*, issue 89, March 2005.

REBECCA WARREN

1. See Edmund de Waal's essay in *A Secret History of Clay: From Gauguin to Gormley*, exh. cat., Tate Liverpool, 2004.
2. Artist in conversation with Carl Freedman, *Rebecca Warren*, Kunsthalle Zurich, 2004, p.21.
3. *Rabelais and His World*, Mikhail Bakhtin, translated by Hélène Iswolsky, Indiana 1984, p.26.

NICOLE WERMERS

1. Artist in conversation with author, 31 October 2005.

CERITH WYN EVANS

1. *Look at that picture … How does it appear to you now? Does it seem to be Persisting?*, interview with Annushka Shani and Cerith Wyn Evans, White Cube, London, 2003.
2. Jan Verwoert and Cerith Wyn Evans, in *Further:Artists from Wales*, 50th International Art Exhibition, Venice; Wales Art International, Cymru, 2003.
3. 'Innocence and Experience, frieze talks to Cerith Wyn Evans', *frieze*, issue 71, November/December 2002, pp.76–81.

THEATRE PIECES

1. *Parachute* 31 (1983), p.11.
2. Ibid. p.19.
3. *Dan Graham: Works 1965-2000*, Richter Verlag, 2001, p.117.

LIST OF EXHIBITED WORKS

Angela Bulloch
The Disenchanted Forest x 1001 2005
Suspended ceiling and floor each 800 x 560, a kilometre
of luminescent string, 105 silkscreen prints on Somerset
welded paper, each 100 x 70, 1001 metal tree number plates
each diameter 3, luminescent text painted directly onto the
wall, various light sources, 7 channel electronic sound track
by Florian Hecker
Collection Helga de Alvear, Madrid

Pablo Bronstein
Plaza Minuet 2006
Performance

Gerard Byrne
An Exercise for Two Actors and One Listener 2006
Performance

Marc Camille Chaimowicz

Here and There... 1979–2006
Slide projections with pendulum, text and furniture designed
by Marcel Breuer for Isokon and glass corner table designed
by the artist
Courtesy the artist and Cabinet, London

Partial Eclipse... 1980–2006
Performance
Re-enacted by Florian Sumi

Lali Chetwynd
The Fall of Man: A puppet extravaganza! 2006
With music by Alexander Tucker
Performance

Cosey Fanni Tutti
Magazine Actions 1973–1980
Printed matter
Courtesy the artist and Cabinet, London

Enrico David

Untitled (Triennial Outlet) 2006
Mixed media. Dimensions variable
Courtesy the artist and Cabinet, London and Daniel Buchholz, Cologne

Includes:

Sessions Outcome Enlarged 2003
Wood, paint and pencil. 265 x 60 x 67
Courtesy the artist, Cabinet, London and Daniel Buchholz, Cologne

Two-minded Outpour (with M.Mc) 2005
Wood, glass, cardboard and computer prints
52 x 52 x 21
Speck Collection, Cologne
Courtesy Galerie Daniel Buchholz, Cologne

Sweet Seizure 2002
Wood, glass, paper collage, cardboard and paint
27 x 21 x 15
Collection of Daniel Buchholz and Christopher Müller
Courtesy Cabinet, London

Measure of Disagreement 2006
Acrylic paint, leather, wood, steel and papier-mâché
Dimensions variable
Collection of Alexander Schröeder
Courtesy Cabinet, London

Peter Doig
Gasthof 2004
Oil on canvas. 275 x 200
Private Collection

Kaye Donachie

Epiphany 2002
Oil on canvas. 36 x 46
Private Collection
Courtesy Maureen Paley

Red and Blue 2002
Oil on canvas. 52.5 x 40
Collection Hunter and Lisa Gray
Courtesy Maureen Paley

Your untold dreams I love to see 2005
Oil on canvas. 56.5 x 42
Collection Mark Fletcher and Tobias Meyer
Courtesy Maureen Paley and Peres Projects, Los Angeles

Ian Hamilton Finlay

Swallow 1999
with Peter Coates
Stone. 200 x 44.5 (diameter)
Courtesy the artist and Victoria Miro Gallery, London

Nymph/Ship 1999
with Peter Coates
Stone. 200 x 44.5 (diameter)
Courtesy the artist and Victoria Miro Gallery, London

Blue Waters Bark 1999
with Peter Coates
Stone. 200 x 44.5 (diameter)
Courtesy the artist and Victoria Miro Gallery, London

Ian Hamilton Finlay and Cerith Wyn Evans
First Suprematist Standing Poem 1965
by Ian Hamilton Finlay
Firework 2006
Courtesy the artists, Victoria Miro Gallery and Jay Jopling/White Cube Gallery
(London)

how blue!	how blue?
how far!	how sad?
how sad!	how small?
how small!	how white?
how white!	how far?

Luke Fowler
Pilgrimage from Scattered Points 2006
DVD projection with stereo sound
Running time: 45 minutes
Courtesy the artist and The Modern Institute, Glasgow
Commissioned by the Dewar Arts Awards

Michael Fullerton

Stuart Christie: I love my world 2006
Oil on linen. 61 x 45
Courtesy the artist and Counter Gallery, London

Dope Smoker, Paranoid 1968 (Phineas Phreak) 2003
Oil on canvas. 36 x 30
Courtesy the artist and Counter Gallery, London

Beatrice Lyall 2006
Oil on linen. 61 x 45
Courtesy the artist and Counter Gallery, London

Gainsborough screenprint 2006
Screenprint on newspaper. Dimensions variable
Courtesy the artist and Counter Gallery, London

Ryan Gander

Robbed us with the sight of what we should have known 2006

Three parts:

Stumbling block:
Milestone produced from concrete fallen from Unité
d'habitation, Marseille, (Le Corbusier 1947–1952) placed
outside a London Borough of Hackney social housing block,
Hoxton, London
C-print. 35 x 30

In search of the perfect palindrome (third attempt):
Crossword featuring a newly invented word 'Mitim' –
rendering it unsolvable – placed in a national newspaper
Newsprint. 22.5 x 37 x 30

A rumour of rest:
Two hundred and fifty-five cork tiles previously used as
a pin board to display research, and form relationships
between documents relating to the production of a legend
around the idea of 'concrete cancer'
Cork tiles. 476.8 x 596

Courtesy the artist and STORE, London and Annet Gelink Gallery, Amsterdam
Supported by Arts Council England

Liam Gillick

Complete Signage (compressed, depressed, repressed, weekday in Sochaux) 2005
Water-cut powder coated aluminium
4 elements, each 200 x 100 x 0.5
Courtesy the artist and Casey Kaplan, New York

Brazil Kalmar Text 2006
Water-cut powder coated aluminium
200 x 100 x 0.5
Courtesy the artist

Kalmar Text 2006
Water-cut powder coated aluminium
200 x 100 x 0.5
Courtesy the artist

Five More Plans (Future/Past) 1999–2006
Text panel
Dimensions variable
Courtesy the artist

Construccion de Uno (version) 2006
With Michael Shamberg, Executive Producer
Performance

Liam Gillick and Philippe Parreno
BRIANNNNNN & FERRYYYYYY 2004
DVD on monitor with stereo sound
Running time: 38 minutes
Courtesy the artists, Air de Paris, Paris, Casey Kaplan, New York, Friedrich Petzel, New York and Esther Schipper, Berlin

Douglas Gordon

Proposition for a Posthumous Portrait 2004
Skull and mirror. Dimensions variable
Courtesy Sean and Mary Kelly, New York

Letter unsent No 13 2005
Mixed media. Dimensions variable
Courtesy the artist and Haunch of Venison

Mark Leckey

Gorgeousness and Gorgeosity 2005

Installation with 4 parts:
Made in 'Eaven 2004
16mm film
Running time: 20 minutes
Tate
Purchased with funds provided by Frieze Art Fair Fund 2004

Drunken Bakers 2005
DVD projection with surround sound
Running time: 60 minutes
Courtesy the artist, Cabinet, London
Drunken Bakers is written by Barney Farmer, drawn by Lee Healey and first appeared in *Viz* comic January 2003

Clock 2005
DVD projection
Running time: 60 minutes
Courtesy the artist, Cabinet, London, Galerie Daniel Buchholz and Gavin Brown's enterprise, New York

Trailer 2005
DVD on monitor with stereo sound
Running time: 55 seconds
Courtesy the artist, Cabinet, London, Galerie Daniel Buchholz and Gavin Brown's enterprise, New York

Linder
The Working Class Goes to Paradise 2000–2006
Performance

Daria Martin

Regeneration 2006
With Zeena Parkins
Performance

Wintergarden 2005
16 mm film, optical sound
Running time: 13 minutes
Courtesy the artist and Maureen Paley
Commisssioned by Film and Video Umbrella and De La Warr Pavilion

Simon Martin
Wednesday Afternoon 2005
DVD projection with stereo sound. Running time: 12 minutes
Courtesy the artist and Counter Gallery, London

Lucy McKenzie

Untitled 2005
Oil on canvas. 243.8 x 183.5
Private Collection, courtesy Metro Pictures

Untitled 2005
Watercolor, collage on paper. 32 x 22.5 x 31.5
Private Collection, Switzerland

Alan Michael
Untitled 2005
Oil on canvas. 164 x 114
Courtesy the artist, Stuart Shave | Modern Art and HOTEL, London

Jonathan Monk
Twelve Angry Women 2005
Vintage drawings with coloured drawing pins
Each 28 x 21
Courtesy Galleri Nicolai Wallner, Copenhagen

Scott Myles

The End of Summer 2001
Two silkscreen prints
103 x 72
50 x 83
Courtesy the artist and The Modern Institute, Glasgow

Untitled 2004
Acrylic, wood and Perspex. 156 x 38.2 x 38.2
Courtesy Shirley Morales and Kevin McSpadden

Christopher Orr

Nothing Will Be As It Was 2004
Oil on linen. 21 x 30.5
Private Collection, Switzerland

All We Need Is The Air That We Breathe 2004
Oil on canvas. 17 x 11.6
Courtesy IBID PROJECTS, London and Vilnius

Hits of Sunshine 2005
Oil on linen. 16.5 x 19
Hauser & Wirth Collection, Switzerland

The Otolith Group
Otolith 2003
DVD projection with stereo sound
Running time: 22 minutes
Courtesy the artists

Djordje Ozbolt

Le Duc 2004
Acrylic on canvas. 40 x 31
Courtesy Private Collection, Switzerland and Herald St, London

Suicide 2004
Acrylic on canvas. 52 x 25
Courtesy Herald St, London

Fountain 2005
Acrylic on canvas. 35 x 25
Courtesy Private Collection, Switzerland and Herald St, London

Love of my Life 2005
Acrylic on board. 43 x 43
Courtesy Herald St, London

L' Afrique c'est chic 2005
Acrylic on board. 61 (diameter)
Courtesy Herald St, London

Untitled 2005
Acrylic on board. 32 x 32
Private Collection, Switzerland

The Last of the Impressionists 2005
Acrylic on board. 51 x 43
Private Collection, Switzerland

Oliver Payne and Nick Relph

Swoon Soon 2006
16 mm film
Running time: 20 minutes
Courtesy the artists and Gavin Brown's enterprise, New York and Herald St, London

Olivia Plender
MONITOR 2005
Performance

Muzi Quawson
Pull Back the Shade 2002–2006
Slide projection
Courtesy the artist

Eva Rothschild
Knock Knock 2005
Leather with steel support. 140 x 289 x 130
Courtesy the artist, Stuart Shave | Modern Art, London
and The Modern Institute, Glasgow

Tino Sehgal
This is propaganda 2002
Tate
Purchased from Johnen + Schöttle Gallery, Cologne (General Funds) 2005

John Stezaker

City 2000–2004
Found photographic image 6.5 x 5.5
Courtesy the artist and The Approach, London

City IV 2000–2004
Found photographic image 4.3 x 5
Courtesy the artist and The Approach, London

City VII 2000–2004
Found photographic image 4.8 x 4.3
Courtesy the artist and The Approach, London

Mask II 1991–1992
Collage 26 x 20
Courtesy the artist and The Approach, London

Mask IV 2005
Collage 21 x 17
Courtesy the artist and The Approach, London

Mask V 2005
Collage 24 x 18
Courtesy the artist and The Approach, London

Mask VII 2005
Collage 21 x 17.5
Courtesy the artist and The Approach, London

Mask VIII 2005
Collage 54.5 x 39
Courtesy the artist and The Approach, London

Reparation I 1999–2005
Found photographic image 11.7 x 12.7
Courtesy the artist and The Approach, London

Reparation II 1999–2005
Found photographic image 29.5 x 26
Courtesy the artist and The Approach, London

Reparation III 1999–2005
Found photographic image 22.4 x 16.5
Courtesy the artist and The Approach, London

Reparation IV 1999–2005
Found photographic image 30 x 30.5
Courtesy the artist and The Approach, London

Rirkrit Tiravanija
Untitled, 2001 (No fire no ashes) 2001
Granite and red rhine stone. Dimensions variable
Courtesy neugerriemschneider, Berlin

Rebecca Warren

H 2006
Reinforced clay, MDF and wheels. 180 x 85 x 85
Courtesy the artist and Maureen Paley

Cube 2006
Bronze, MDF and wheels. 146 x 135 x 136.5
Courtesy the artist and Maureen Paley

The Hostess 2006
Reinforced clay and plinth. 250 x 86 x 95
Courtesy the artist and Maureen Paley

Fido 2006
Reinforced clay, wood, plinth and Perspex. 198 x 87 x 45
Courtesy the artist and Maureen Paley

Come, Helga 2006
Reinforced clay, paint, plinth and Perspex. 215 x 61 x 154.5
Courtesy the artist and Maureen Paley

Hélène 2006
Reinforced painted clay and plinth. 140 x 35 x 35
Courtesy the artist and Maureen Paley

Versailles 2006
Reinforced painted clay and plinth. 160 x 35 x 35
Courtesy the artist and Maureen Paley

Nicole Wermers

Untitled (Forcefield) 2005
Steel. Dimensions variable
Courtesy the artist and Herald St, London

Untitled (Ashtray) 2005
Steel, rust and sand. 84 x 28 x 28
Private Collection, London
Courtesy the artist and Herald St, London

Untitled (Ashtray) 2005
Steel, styrene, laquer and sand. 84 x 28 x 28
Private Collection, London
Courtesy the artist and Herald St, London

Cerith Wyn Evans
In Girum Imus Nocte et Consumimur Igni 2006
Neon. 30 x 300 (diameter)
Courtesy the artist and Jay Jopling/White Cube (London)

CREDITS

REFERENCE IMAGES

Each artist was asked to supply a reference image to appear alongside their own work on the artist pages.

1

Pablo Bronstein
Clore Gallery, Tate, London
1980–1985
Designed by James Stirling (1926–1992)
Tate

2

Angela Bulloch
Adolf-Luther-Stiftung, Krefeld
20 March 2004
Studio of Adolf Luther (1912–1990)
Courtesy Angela Bulloch

3

Gerard Byrne
Newspapers
13 December 2005
Courtesy Gerard Byrne

4

Marc Camille Chaimowicz
Hôtel Le Moderne, Menton
9 April 2004
Courtesy Marc Camille Chaimowicz

5

Lali Chetwynd
Alexander Calder, Whitney Musuem of Art, 1971
Alexander Calder
Circus Lion (1926–1931)
Courtesy Marvin W. Schwartz

6

Cosey Fanni Tutti
London Call Girl Scandal
1960s
Poster for Sunday Pictorial
Courtesy Cosey Fanni Tutti

7

Enrico David
Studio 54
From *Disco!* by Albert Goldman (1927–1994)
1978
Photograph by Sonia Moskowitz
Hawthorn Books

8

Peter Doig
Painted sign, Trinidad
2005
Courtesy Peter Doig

9

Kaye Donachie
Strange News from Another Star
Herman Hesse (1877–1962)
1976
Cover design David Pocknell
Penguin Books

10

Ian Hamilton Finlay
Nicolas Poussin (1594–1665)
Et in Arcadia Ego 1637–1639
Oil on canvas. 185 x 121
Musée du Louvre, Paris

11

Luke Fowler
Richard Dottridge photographed after serious car accident
1937
Photographer unknown
Collection of Mary Dottridge

12

Michael Fullerton
Stuart Christie
Photograph by the Brigada Político-Social, General Franco's Secret Police in security headquarters, Puerta del Sol, Madrid
15 August 1964
Courtesy Stuart Christie

13

Ryan Gander
National Physics Laboratory Super Black
Courtesy of the National Physics Laboratory

14

Liam Gillick
Wood Cut
Courtesy Liam Gillick

15

Douglas Gordon
Manchester United's George Best relaxes at home playing cards, Manchester, England
5 September 1964
Courtesy Alamy Images

16

Mark Leckey
Thomas Gainsborough (1727–1788)
Mrs Mary Robinson ('Perdita')
ca. 1781
Canvas, relined 234 x 153
Reproduced by permission of the Trustees of the Wallace Collection

17

Linder
Sister Marguerite Frost as Jesus
Easter pageant at Canterbury, New Hampshire
1932
Courtesy Canterbury Shaker Village, Canterbury, New Hampshire

18

Lucy McKenzie
Wall painting, Brussels
2004
Courtesy Lucy McKenzie

19

Daria Martin
Carolee Schneemann (born 1939)
Interior Scroll
Performance photograph: August 29 1975 Women Here & There Now East Hampton L.I.
Courtesy Carolee Schneemann

20

Simon Martin
Jean Baudrillard
Paris 1986 1986
Photograph. 30 x 45
Courtesy Neue Galerie Graz am Landesmuseum Joanneum, Austria

21

Alan Michael
Jörg Immendorff (born 1945)
We're Coming 1983
Relief print on paper. 180.3 x 229.4
Tate. Purchased 1984

22

Jonathan Monk
Chris Burden (born 1946)
Trans-Fixed
Venice, California: April 23, 1974
Courtesy Chris Burden

23

Scott Myles
International exhibition of new theatre technology,
Schubertsaal Concert Hall, Vienna
1924
Designed by Friedrich Kiesler (1890–1965)
Courtesy Österrichische Friedrich und Lillian Kiesler-Privatstiftung, Wien and
Rijksbureau voor Kunsthistorische Documentatie, Theo van Doesburg Archive
(Van Moorsel Donation)

24

Christopher Orr
Understanding Science (No. 77)
1964
A Sampson Low Publication

25

Otolith Group
Handsworth Songs
1986
Still from film
Courtesy Black Audio Film Collective

26

Djordje Ozbolt
Untitled 2005
Collage
Courtesy Jovan Colic and Djordje Ozbolt

27

Nick Relph and Oliver Payne
Alien Power
T-shirt design
Courtesy Nick Relph and Oliver Payne

28

Olivia Plender
*Kibbo Kift Kin members outside their tent, at the Second
Dexter Fam camp*
1928
Photographer unknown
Courtesy Kibbo Kift Foundation and The Museum of London

29

Muzi Quawson
Taxi Driver Directed by Martin Scorsese (born 1942)
Poster
1976
Courtesy Photofest

30

Eva Rothschild
Buddha hand, Sravanagelgola, India
2004
Courtesy Eva Rothschild

31

Tino Sehgal
Response by the Lettrist International to a question posed
by René Magritte
La Carte d'après nature
June 1954
Edited by René Magritte (1898–1967)
René Magritte, *La carte d'après nature*
© Magritte Foundation / DACS, London, 2006

Response to the question: 'Does thought enlighten both us and
our actions with the same indifference as the sun, or what
is our hope, and what is its value?'

LA CARTE D'APRÈS NATURE, June 1954
Special issue edited by René Magritte

(…)

A complete civilization will have to be built: one in which
all forms of activity tend perpetually towards an affective
unsettling of life.

We have begun to address the problem of leisure —
which is already being discussed, despite the fact that the
working classes have only recently escaped the burden of
uninterrupted labor — and which tomorrow will be the
only problem.

The great civilization that is on its way will construct
situations and adventures. A science of life is possible.
The adventurer seeks out and creates adventure, rather
than wait for it to come. The conscious use of environments
will condition constantly renewed behaviors. The role of
those small flights of chance which we call fate will con-
tinue to fade. An architecture, an urban planning and
a mood-affecting form of plastic expression — the first
principles of which exist today — will work in concert
toward this end.

The practice of de-familiarization [trans: *depayse-
ment*, also displacement] and the choice of encounters, the
sense of incompleteness and ephemer-ality, the love of
speed transposed onto the plane of the mind, together with
inventiveness and forgetting are among the elements of an
ethics of drifting (ethique de la derive) which we have
already begun to test in the poverty of the cities of our time.

A science of relations and ambiences, which we call
psychogeography, is being developed. It will give play in
the society of others [trans: *le jeu de societe*, literally "the par-
lor game"] its true meaning: a society founded upon play.
Nothing is more serious. Amusement is the royal privilege
that must be made available to everyone.

Happiness, Saint-Just proclaimed, is a new idea in
Europe. This program is only now becoming realizable.

Sovereign attraction, which Charles Fourier discov-
ered in the free play of passions, must be ceaselessly rein-
vented. We will work to create new desires, and will spare
no effort in promoting them.

We will be the ones to infuse social conflict with the
only authentic rage. Revolution isn't made by demanding
25,216 francs per month. Now is the time to seize control
of life [trans: *gagner sa vie*, literally "to earn a living"],
a completely material life in which everything is achiev-
able: Very little is to be expected of the strength and power
of the mind.

Paris, May 5, 1954

For the Lettrist International:
Henry de BEARN, Andre CONORD,
Mohamed DAHOU, Guy-Ernest DEBORD,
Jacques FILLON, Patrick STRARAM,
Gil J. WOLMAN

[Editor's note: translated July 1998 by Nick Tallett.]

32

John Stezaker
Édouard Manet (1832–1883)
The Dead Christ and the Angels 1864
Oil on canvas. 179.4 x 149.9
Metropolitan Museum of Art, H. O. Havemeyer Collection, Bequest
of Mrs. H. O. Havemeyer, 1929

33

Rebecca Warren
Delos: column with dedicatory inscription to Athena
ca. 525–500 BC
Courtesy Centre for Study of Ancient Documents, Oxford

34

Nicole Wermers
Arctic Cathedral, Tromsø
Designed by Jan Inge Hovig (1920–1977)
1964–1965
Courtesy Nicole Wermers

35

Cerith Wyn Evans
Proposal to remove a column from the façade of Tate Britain
2000
Collage. 22.78 x 18.08
Courtesy Cerith Wyn Evans

PHOTOGRAPHIC CREDITS

All photographs are courtesy the artist unless otherwise stated.

REF **5**
Marvin W. Schwartz

REF **7**
© Sonia Moskowitz

REF **10**
© The Bridgeman Art Library

REF **15**
© POPPERFOTO / Alamay

REF **18**
Anthony McCall

REF **19**
Neue Galerie Graz am Landesmuseum Joanneum

REF **21**
Charles Hill

REF **22**
Rijksbureau voor Kunsthistorische Documentatie

REF **27**
Kibbo Kift Foundation

REF **32**
© 1980 The Metropolitan Museum of Art

REF **34**
L.H. Jeffrey Archive, University of Oxford

REF **35**
K.H. Wermers